D0623615

TALL 21849
Z
43 Wong, Frederick
.W9
 The complete cal-
 ligrapher

DATE DUE			
JUN 22 '81			
NOV 6 '81			
FEB 8 '82			
APR 8 '82			
JUL 5 '82			
OCT 18 '82			
APR 24 '84			
MAY 7 '84			
DEC 26 '84			
JAN 30 '86			
DEC 8 '86			
APR 27 '87			

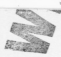

WITHDRAWN

LAKE TAHOE COMMUNITY COLLEGE
LEARNING RESOURCES CENTER

The Complete Calligrapher

Frederick Wong

21849

LAKE TAHOE COMMUNITY COLLEGE

LEARNING RESOURCES CENTER

Copyright © 1980 by Watson-Guptill Publications

First published 1980 in the United States and Canada by Watson-Guptill Publications,
a division of Billboard Publications, Inc.,
1515 Broadway, New York, N.Y. 10036

Published in Great Britain by Pitman House Ltd.,
39 Parker Street, London WC2B 5PB
ISBN 0-273-01623-7

Library of Congress Cataloging in Publication Data
Wong, Frederick, 1929-
 The complete calligrapher.

 Bibliography: p.
 Includes index.
 1. Calligraphy. I. Title.
Z43.W9 745.6'1977 80-19222
ISBN 0-8230-0778-2

All rights reserved. No part of this publication may be
reproduced or used in any form or by any means—graphic,
electronic, or mechanical, including photocopying, recording,
taping, or information storage and retrieval systems—
without written permission of the publishers.

Manufactured in U.S.A.

First Printing, 1980

The
Complete
Calligrapher

WATSON-GUPTILL PUBLICATIONS/NEW YORK
PITMAN HOUSE LIMITED/LONDON

Dedication

I taught a beginner's calligraphy class one fleeting summer two years ago at the Nissequoque Point Beach Club in St. James, New York, where we regularly spend our Julys and Augusts. The class gathered two afternoons a week on the screened-in veranda of the clubhouse, where we practiced the Italic hand. My students numbered about 12 and ranged in age from 8 to 12. The Huntingtons, Van Praaghs, Delafields, Wongs, and the Donahue, Smythe, and van derMarck boys all participated, though, understandably, not always with unbridled enthusiasm and concentration—having been wrenched from tennis courts, off the decks of Sunfishes, and out of sand and surf. Nonetheless, at summer's end they had all become somewhat aware of the beauty found in written letters.

For my part, I hold the class of '78 in fond regard and it is to them I dedicate *The Complete Calligrapher*.

5181·BrodArt· $17.50

History & Purpose

IN OUR ENTHUSIASM for writing beautifully, we often forget that the lovely hands we practice so diligently today represent the graphic distillations of human effort over thousands of years. It is an effort, frequently made with the most primitive tools, to permanently record images of the mind and heart. This instinct to communicate, dating from the earliest cave paintings, is the source of today's calligraphic revival. The ages in between—from that smoky outline of a handprint in a remote French cave announcing the presence of Man to the publication in 1906 of Edward Johnston's outstanding volume on the art of writing—are filled with events signifying the invention and the development of the written word.

SUMERIAN, EGYPTIAN, AND CHINESE WRITING

Sumer, the biblical land of Shiner, produced the first written language. Located at the head of the Persian Gulf between the Tigris and Euphrates Rivers (what is now Iraq), the Sumerian civilization developed a writing system in which pictorial symbols were scratched into clay tablets. Inscribing with a pointed instrument was replaced by imprinting with the end of a triangular-shaped reed or stylus. This produced a cleaner, crisper image than the previous scoring technique, which produced rough edges of excess clay. The changes in tool and technique also altered the character of the writing from curved to linear forms. The name *Cuneiform* (derived from the Latin *cuneus*, meaning wedge) is descriptive of the triangular-stroke imprints. Sun-dried examples of these clay tablets (dating back to 3100 B.C.) have survived to this day.

The Egyptian system of writing, familiarly known as Hieroglyphics, actu-

Wedge-shaped strokes of Cuneiform symbols.

Egyptian Hieroglyphic, Hieratic, and Demotic forms.

Chinese pictograms and ideogram for "rain".

ally included three script forms. In addition to the Hieroglyphic, reserved for sacred inscriptions, there was the Hieratic, a cursive form used by the Egyptian priesthood, and the Demotic, used for everyday affairs. The Egyptian civilization produced a writing system that incorporated symbols representing both syllables and sounds; however, it did not quite achieve a full range of alphabetical symbols and so is considered pictogrammatic rather than phonetic. Hieroglyphic characters did, however, include the use of phonograms—picture representations of sounds. For example, a phonogram in English might be drawings of a bee and a leaf combined to represent the word "belief." This sophisticated use of symbols was never achieved by the Sumerians and, indeed, brought the Egyptian civilization within one step of the nearly perfect alphabet. As Frederic W. Goudy comments in his book *The Alphabet and Elements of Lettering*, "Unfortunately that 'simple step' the Egyptians themselves never took, but continued the use of eye pictures side by side with ear pictures, combining both, instead of disregarding the pictograms and employing only fixed signs for certain sounds."

Chinese calligraphy developed independently of the Middle East, as China was an isolated civilization for thousands of years. In fact, trade routes with the European continent were not established until the Venetian, Marco Polo, traveled to China in A.D. 1275 and served in the court of Kublai Khan. Chinese writing was in full flower then. Their system of pictograms had evolved into ideograms, where monosyllabic

characters represented an entire word. This was quite unlike the Western system familiar to Marco Polo, in which a combination of signs or letters formed words. These ideograms are still in use today and have remained basically unchanged for 3,000 years. As Chiang Yee comments in *Chinese Calligraphy*, "It is not an exaggeration to assert that a Chinese child of seven or eight years can read the 'Four Books'—the Confucian Classics—though these were written at least 2,400 years ago."

It might seem there is little reason to even discuss Chinese calligraphy in terms of the development of Western writing. There are more differences than similarities, at least superficially: The Chinese use a soft hair brush to form their characters on an absorbent paper and classically write in vertical columns from right to left. However, what should be meaningful to us is that calligraphy in the Orient goes beyond mere graphic representation of language. It is considered an art form and esthetic considerations are valued as much or more than the content of the words themselves—truly, the medium is the message! The formation of each stroke is critical and is constructed to convey strength and boldness or delicacy and resilience. The sure, firm hand can be as easily detected as the hesitant and wavering. The Chinese view calligraphers with the same attitudes of criticism and respect the West accords its finest painters.

THE ALPHABET AND THE ROMAN LETTER

Today's alphabet consists of 26 symbols, each representing a sound. It is, therefore, phonetically conceived and owes its heritage to the Phoenician al-

Phoenician alphabet, read from right to left.

phabet of 22 letters, which dates back to about 1600 B.C. The Phoenicians, early offshoots from Semitic stock, inhabited a coastal strip of the Mediterranean (now Syria). They were traders and carriers of goods between Egypt and Greece and as far west as Spain. There is evidence, as a result of this commercial relationship, of the influence of Hieroglyphics on the Semitic letters. Early forms of Phoenician inscriptions had many features in common with the oldest Egyptian writings. The Greeks in turn adopted the Phoenician alphabet around 1000 B.C., adding five vowels, and by 403 B.C. adopted a revised alphabet of 24 formalized letterforms. The

Greek alphabet, read from left to right.

word "alphabet" evolved from the Greek pronunciation of their first two letters, *alpha* and *beta*. The Romans

subsequently modified this Greek alphabet, accepting 13 letters unchanged, revising eight, and adding two. The total of 23 was sufficient for writing Latin. The letters *J*, *U*, and *W* did not exist in the classic Roman alphabet and it was not until the 10th century that the *U* was added, the *W* in 12th-century England, and the consonant *J* in the 15th century.

The Roman contribution to the development of today's alphabet goes far beyond its modifications and the addition of two symbols. The Romans also changed the pronunciation of each letter, from the Greek *alpha, beta, gamma, delta,* and so on, to our current *A, B, C, D* sounds. Even more significant was their heightened awareness of the letterform, culminating in that famous stone inscription carved in the base of the Trajan Column (ca. A.D. 114).

CLASSIC ROMAN

These beautifully conceived and executed Roman majuscules (in all likelihood painted on with a brush before being chiseled into the stone) have exerted their influence on hand lettering and typography for almost 2,000 years.

CAROLINGIAN AND MEDIEVAL (GOTHIC)

With the establishment of the Greek and Roman alphabets, emphasis on what one writes gradually shifted to how one writes. The choice of tools and materials took on new importance. We know the Sumerians first used a pointed instrument to inscribe their symbols into damp clay, then utilized a wedge-shaped reed that they impressed into clay tablets. The Egyptians inscribed in limestone and wrote with both brush and reed pen on papyrus, a papery material made from the pith of the plant's reeds. The Greeks and Romans chiseled letters in stone, incised in wax tablets with a pointed instrument, and wrote with reed pens on papyrus. It is unclear when the quill pen was developed, although St. Isidore of Seville refers to it as early as A.D. 625. We have examples of bronze pen nibs made by the Romans and evidence of brass, iron, and steel pens used for Blackletter as early as A.D. 1550. Curiously, metal nibs did not gain wide popular recognition until well into the 19th century. The use of treated animal skins, vellum, and parchment supplanted all other writing surfaces in Europe as early perhaps as the 10th century. At first restricted to court and religious writings, their use became more general until, in the 15th century, the invention of printing spurred paper production.

The classic Roman majuscules of the Trajan Column represented letter design of the highest order. Attempting to duplicate these sculpted shapes with a broad-cut quill was difficult and tedious; manuscripts of the period with pen-lettered square Roman capitals reflect this painstaking effort. It was natural that a more fluid hand, called Rustica, became popular in the fourth century and served as the book hand of the Roman Empire until the sixth century.

Manuscripts dated as late as the 11th century have been found in which Rustica initials were used for emphasis.

Concurrent with the use of Rustica were two other literary hands, Uncial and Half Uncial. Both are of great importance, since a hint of the use of minuscules is found in their letter forma-

ROMAN UNCIAL

tion. Although Uncial letters were used by the Greeks as early as the third century B.C., their name derives from Roman letterforms that, at least in the earliest examples, measured a precise Roman *uncia* or inch in height. Perhaps less by intent than by the natural result of writing more quickly, certain Uncial letters began to show strokes extending above and below the uniform height of Roman capitals. The Half Uncial showed an even more obvious movement toward minuscule letters, with fairly pronounced ascenders and descenders. It is even thought that four construction lines were probably used in their formation, rather than the two required for Roman capitals.

half uncial

The ensuing chaos following the fall of the Roman Empire in the fifth century was reflected in the development of writing. Monks and scholars were able to keep the art alive, but under very insular circumstances. The result was a proliferation of "national hands"—

IRISh half uncial

writing styles that varied from one land to another—which did not contribute substantially to the evolution of letter development. The best were those that retained some of the simplicity and clarity of the Roman letters. Of particular note was the Irish version of the Half Uncial, as exemplified in the famed Book of Kells (seventh century).

carolingian

It was not until the latter part of the eighth century, in France under Emperor Charlemagne, that a script called Carolingian or Caroline came into such prominence that it supplanted the many local styles then in use. Its significance in the history and development of letters is equal to that of the Roman letter. Until the appearance of the Carolingian script, all letterforms were capitals. The Carolingian, however, was a true minuscule, as familiar and as comprehensible as any small letter seen today. (It should be noted that this hand is considered a "small letter" form because the ascenders and descenders are very emphatic and require a four-construction-line approach. There are no Carolingian majuscules as such; it is not until the advent of Blackletter that

we have a majuscule form designed to work solely with minuscules.) The use of Carolingian, as mandated by Charlemagne's edict, renewed interest in art and learning generally, and manuscripts of all kinds were recopied in this new hand. It became the first legitimate attempt to establish a standard hand for all of western Europe since the fall of the Roman Empire 300 years earlier. It was the Carolingian script that inspired the humanistic writing of the 15th century, which, in turn, was the foundation for our lower-case Roman letters in typography.

From the ninth to the 11th centuries, Carolingian flourished as the dominant European hand. The Gothic influence, however, gradually came to the fore during the 12th century. This reflected both changing tastes as well as the normal variations that develop when many people write in a common hand. The Carolingian roundness gave way to a Gothic angularity. Spacing between letters as well as space within letters became regulated in size and the letters were compressed and more vertical in emphasis. The Gothic hand reached its

Gothic Blackletter

fullest expression in the 15th century, when its appearance of unrelieved density gave rise to the name Blackletter. Although today it is commonly referred to as "Old English" or even "Christmas" lettering, a more accurate name would be "Textur" or "Textura," from the Latin *textum* (meaning woven fabric or texture) because of its even patterning. The Gothic style gave us our first deliberate use of majuscules and minuscules in combination.

ITALIC SCRIPT, THE HUMANISTIC HAND

The Humanist movement, which we've come to know as the Renaissance, began in Italy in the 14th century. Here the Gothic hand maintained a degree of roundness more like that of Carolingian letters, which resulted in letterforms that were less severe and rigid. As the

Italian Gothic

Gothic period reached its peak in the 15th century in other European countries, Italy was already totally occupied with a Roman revival. Artists, scholars, and scribes dedicated themselves to the study and emulation of the earlier Latin culture. It was inevitable that Caroline letters would also be rediscovered and remodeled; the results were beautifully evident in Humanist writings. Letters became more generously round and graceful, with spacious counters and firm, strong ascenders and descenders. They were almost the antithesis of the Gothic style—less stern, more exuberant, less cramped, more open.

humanist

The Italic hand probably developed from writing humanistic letters quickly. In addition to slanting the forms slightly, this also altered the letter proportions, eliminated the need for many penlifts, and caused more upstrokes and joins. The earliest examples of Humanist Cursive are attributed to Niccolo Niccoli, in writings dated toward the beginning of the 15th cen-

Chancery Cursive

tury. Chancery Cursive, a more ornate italic script, is credited to Ludovico degli Arrighi, who taught it using the first printed instructional book, *La Operina*, published in Rome in 1522.

COPPERPLATE

The Copperplate hand was not a logical development in the history of letters. Its italicized characteristics can be related to Humanist Cursive, but its appearance must be attributed to the engraver's tool and the invention of the printing press by Gutenberg in the mid-15th century. The printing press, designed for quantity production, transferred the design of letterforms from the scribe to the type designer. At first the printer and type cutter attempted to duplicate calligraphic hands, but soon discovered it more advantageous to design type specifically for the machine, using historical letterforms only as a foundation. The result was a greater emphasis

Copperplate is written with an elbow pen at a very severe angle and requires continuous penlifts.

on cutting plates and dies. Hand lettering then attempted to emulate the fine-line scratchings of the engraver's stroke, which ultimately led to abandoning the square-cut nib for the pointed pen. In fact, an active competition developed between engraver and scribe to achieve the most delicate hair lines, ultimately to the detriment of clarity and the letterform. Along with delicate strokes, loops and flourishes were added, often to a fault—perhaps reflecting the influences of the Baroque and Rococo.

Copperplate is also referred to as English Roundhand (although there was also Spanish, French, and Italian Roundhand), Spencerian, or Banknote Script. Its influence is evident in much of contemporary penmanship, at least to those of us who were taught by the Palmer method at an early age and learned to produce endless streams of continuous ovals, loops, and jagged diagonals. At its best, Copperplate is a rich, flowing script, almost voluptuous in character. At its worst, it is overly ornate, excessively flourished, and at times almost impossible to read with comfort.

CALLIGRAPHY TODAY, THE FORMAL AND ITALIC HANDS

Today's calligraphic revival can be credited to many people, but particularly to William Morris, a Victorian poet and

ROMAN CAPITALS combine beautifully with the formal Humanist BOOKHAND

craftsman, who, from 1870 to 1875, produced writings based on a version of Arrighi's *La Operina*. Equally influential was Edward Johnston's text *Writing & Illuminating & Lettering*, published in England in 1906, which included an Italian "formal" hand in extensive detail. The significance of these two works is even greater when one notes that both efforts were made when Copperplate was still in full flourish.

Modern Italic

The popular hand of today, of course, is the Italic. This is understandable since its form suggests ease, clarity, and beauty achieved with seemingly little effort. The simple fact that it is "slanted writing" establishes a contemporary kinship. My own thought, however, is that an Italic hand of higher quality could be achieved by first practicing the formal hand—the Humanistic Italian Bookhand—which emphasizes fuller strokes and penlifts.

THE DESIGN FACTOR

Of particular concern to me—and the impetus for writing this book—is the need for a greater awareness of design in calligraphy. Great energy is spent practicing the many traditional lettering styles now available to us, to the point that we often lose sight of the need to assemble these small components into a viable whole. In forming letters we are, of course, practicing design—balance, proportion, and the use of space being essential to writing attractive letters. If we interpret good design to mean "creative planning," then even the simple exercise of placing a three-line address on an envelope becomes a design decision. Certainly after one achieves basic calligraphic competence, then it is design—the organization of disparate elements into an esthetically pleasing whole—that becomes vitally important.

Materials & the Studio

To perform any craft successfully, an understanding of its tools and materials is essential. The act of writing is simple enough, but beautiful writing—calligraphy—is another matter, requiring more than just good esthetic instincts. It is one thing to be able to conceptualize, another to execute. A good working knowledge of pens, inks, and papers is essential if the calligrapher is to choose the combination of materials that will best serve his needs.

This chapter will discuss many of the tools and materials available; however, I'm not suggesting that all these items are necessary for calligraphy. They represent suggestions and alternatives. A broad-edge pen, for example, is designed to draw a clean, wide line; whether the artist favors a Speedball or a Mitchell pen is not significant. Only the results matter. The choice between two nibs designed to perform identical functions is entirely up to the individual artist and how his hand responds to the tool.

It *is* valuable, however, to test a broad range of tools, inks, and papers to learn how they feel in handling and how well they perform. This chapter will describe a variety of pens—metal nibs, plastic nibs, and quills you make by hand—pen holders, reservoirs, fountain pens, inks, and papers, as well as such studio equipment as drafting boards, T squares, and lighting.

PENS AND NIBS

The artist has a great deal of choice when it comes to buying pens and the final decision is really one of personal preference. It is a good idea to have at least one set of broad-edge nibs in a range of widths. Pointed nibs will be needed only for Copperplate lettering and, while many varieties are available,

only a few are stiff enough to produce very fine hairlines yet flexible enough to easily make the swelling strokes. Whichever pointed nib is finally selected, several should be kept on hand since they seem to deteriorate faster than broad-edge nibs. A calligraphic fountain pen is also handy to own for practice work. It can be purchased with one nib or as part of a prepackaged set that includes a range of nibs and an ink cartridge.

Reservoirs are either permanently mounted on chiseled pens and sold as a unit, or sold separately in the case of detachable nibs and holders. However, most prepackaged sets usually include reservoirs, nibs, and even a pen holder. Pointed nibs do not require reservoirs, since a large supply of ink might interfere with drawing fine lines. A reservoir would also probably inhibit flexibility, preventing the nib from making the pressure strokes required in Copperplate.

METAL NIBS

The steel nib, made to be inserted into a pen holder, falls into two general categories. One is a pointed nib that has a single slit at its tip; the other is a broad-edge pen with slits apportioned across the width of the tip.

The pointed nib, a common schoolroom item along with the inkwell, began as a sturdy, well-made nib of nickeloid, constructed to withstand the pressures of young hands performing Palmer or Spencerian exercises. This basic nib was later combined with permanent holder and an ink reservoir to become the fountain pen. The pointed nib could draw a reasonably thin line of uniform width and, until the advent of ball-point and felt- or plastic-tip pens, was the most widely used instrument for ordinary writing purposes.

The less familiar broad-edge pen is designed to create a stroke containing both thick and thin areas without exerting undue pressure. The line created re-

The sturdy pointed nib of nickeloid was a common schoolroom item years ago.

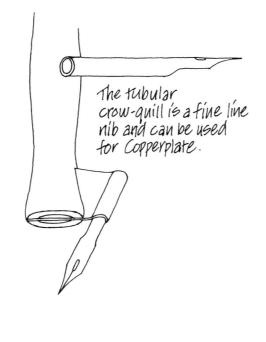

The tubular crow-quill is a fine line nib and can be used for Copperplate.

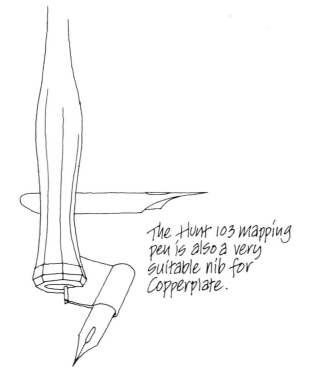

The Hunt 103 mapping pen is also a very suitable nib for Copperplate.

lies solely on the pen's chiseled writing edge and its movement while held at a consistent angle.

The Pointed Nib. Today, for calligraphic purposes, pointed-nibbed pens are much more refined and made in greater variety than the sturdy tool in use earlier in this century. Other than the elbow nib and the crow-quill, used for the Copperplate hand, the metal, single-point pen varies principally in its flexibility and the fineness of its drawn line.

1. The Gillot Series. This packaged card, No. 3579, contains 10 nibs, including several crow-quills, along with three wooden holders, and brief descriptions of their specialized functions. A particularly fine nib is No. 303, which is used in conjunction with the elbow holder for Copperplate.

2. The William Mitchell Elbow Pen Series. This English firm used to have a packaged series of 10 elbow nibs on the market, each of varying design and flexibility. One was not actually a true elbow, but had a long straight shank with only the tip angled to the right. Unfortunately, this collection is no longer available and in its place the company now provides a card containing 10 identical nibs along with a plastic holder. With some diligence and luck, however, you may still discover elbow nibs sold loose from boxed assortments in older, established art-supply stores.

3. The Hunt Mapping Pen. No. 103. I find this nib the most suitable pointed pen for Copperplate lettering. It is a simple straight nib, unlike the Mitchell elbow pens or the tubular-shank crow-quill. Its distinctiveness lies in its point, which is capable of drawing a very fine

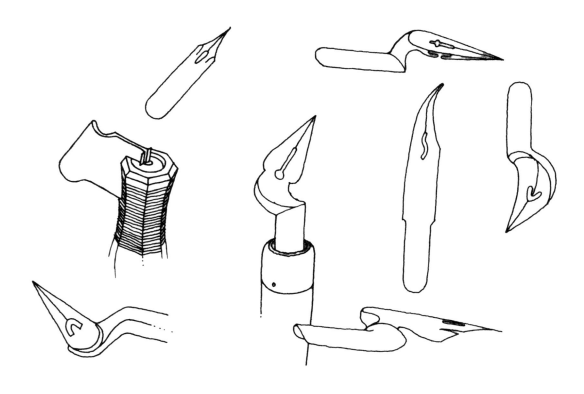

A variety of pointed elbow nibs.

line, and the flexibility of its flanges. The pen responds well to pressure when forming the necessary "swells" of Copperplate, yet is resilient enough to spring back to a point immediately to draw the hairlines.

The Broad-Edge Pen. These nibs, today's answer to the quill pen, are made in abundant variety. They all perform the same function and vary only in physical shape, range of widths, or reservoir design. In some cases the pen looks quite different—the Boxall steel brush, for example, but it, too, is designed to draw thick and thin strokes. In all cases, the actual edge that contacts the writing surface is chiseled, the nib is split for both flexibility and ink movement, and the pen has a reservoir that can retain a quantity of ink.

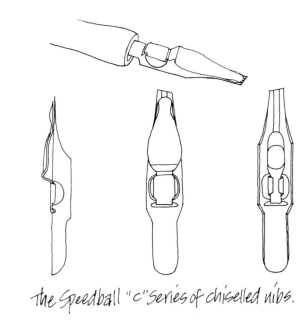

the Speedball "c" series of chiselled nibs.

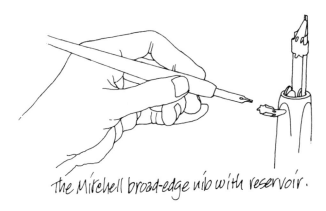

the Mitchell broad-edge nib with reservoir.

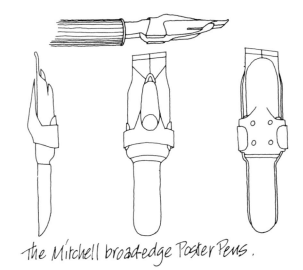

the Mitchell broad-edge Poster Pens.

1. *The Speedball "C" Series.* This particular group of nibs ranges in size from the C–O, which is about 3/16 of an inch (5 mm) in width, diminishing to a very thin C–6. The reservoir is a molded brass sheath fitted permanently to the top of the nib. American made, this series is probably the most familiar and available of all lettering pens and is generally recommended to beginning calligraphers.

2. *The William Mitchell Series.* This old and renowned English firm produces excellent broad-edge pens as well as other more specialized nibs. Unfortunately, they and other manufacturers began prepackaging their products, and this means you will frequently get more nibs than you might need. Their Roundhand Series contains 10 nibs in graduated sizes and a holder with a built-in reservoir that fits underneath the nib. The Italic Series has 10 nibs of five different sizes and uses a slip-on reservoir.

Another interesting series of Mitchell nibs are their Poster Pens, made for large lettering using paint rather than ink. These nibs are packaged in sets of eight, the broadest being 3/8 of an inch (9.5 mm) wide. A large, brass reservoir is permanently mounted underneath and a removable one seated on top. This second reservoir has a little larger gap above the pen surface than most nibs so the heavier paint solution can flow with ease.

The dual reservoir system is unique, and only needed on pens designed for thinned-down paints. The larger bottom reservoir holds the bulk of the mixture, while the top reservoir serves to guide and control the flow.

3. *The Pelikan Pen Series.* This German set of nibs is extremely well machined and comes in a set that includes

a vast range of nibs, a small tube of ink designed for these pens, and a protective carrying case with individual fittings for each nib, as well as the holder. The nibs are available in assorted sizes and all have top-mounted, permanently attached steel reservoirs made to swivel for easy cleaning. These pens can only be fitted into a Pelikan holder.

4. The Heintze and Blanckert "TO" Series. These pens are also made in Germany and come on a card containing six nibs, each with top-mounted steel reservoirs. A plain, stubby, wooden handle, slotted at each end to accommodate two nibs at a time, is also included.

5. The Boxall Pens. These English pens, called automatic lettering pens, are also referred to as steel brushes because of their ability to produce large strokes. Viewed in profile, the nib is diamond shaped. The opening is the reservoir and is capable of holding a large quantity of ink or paint. The writing edge consists of two lips of steel pressing against each other with a series of tiny slits across the width of its top flange. The nib is permanently installed in the handle, and the series has six graduated sizes, the largest being 3/4 of an inch (19 mm).

PLASTIC NIBS
Perhaps the most interesting tools available on the market today for calligraphy are pens that incorporate a plastic substance, either wholly or in part, into their writing edges.

It is exciting to see modern-day materials and technology being utilized for the calligraphic arts. One may hope these new developments will eventually lead to the "perfect" writing tool—a pen that will produce and maintain a crisp, clean edge indefinitely, have a self-contained supply of water-

The Pelikan Pen Series with swivel reservoir.

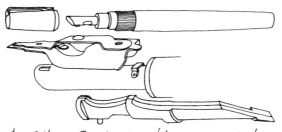

The Pelikan Pen holder with component pieces.

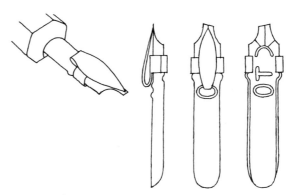

The Heintze and Blanckert "TO" Series of nibs.

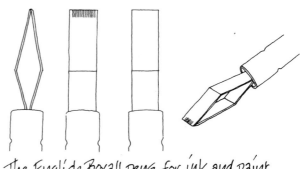

The English Boxall pens for ink and paint.

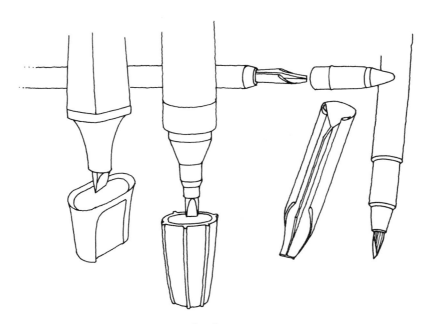

The Braun Quill pen with a rolled plastic nib and other square-cut synthetic markers

proof ink, and be priced for mass consumption. At the moment, however, they do not seem to have the crispness or durability of metal nibs.

The Braun Quill Series. This three-piece unit—barrel handle, nib, and protective cap—is entirely made out of translucent white plastic and compares favorably to some metal nibs. Its durability has yet to be established however, since it is a relatively new product. The removable nib is made from one continuous piece of plastic that is rolled and tucked into a small cylinder, with one end beveled and cut. The effect is much the same as a genuine quill pen. They are available in three sizes, the largest having a stroke width of about 1/8 of an inch (3.2 mm).

Felt-Tip Pens. The writing tip of these self-contained pens—indeed, of the entire "nib"—was originally made entirely of a feltlike substance that drew ink to its edge by capillary action. Today, however, these pens are much sturdier. They have plastic tips soft enough to feel pleasant while writing, yet sufficiently rigid to hold a clean edge for a surprising length of time. The inks they contain, both permanent and impermanent, are brilliant in intensity and surprisingly dense. Colors available span virtually across the entire spectrum. All of these pens are very handy for layout and demonstration work and are ideal as an introductory tool for students. However, they are neither intended nor recommended for fine calligraphy. When new they can produce fine lines of some delicacy, but they lose their edge quickly compared to the metal nib or the Braun quill. Furthermore, while the inks appear dense at first glance, overlapping strokes show they are actually translucent—a darker patch appears where one stroke covers another.

MAKING YOUR OWN PEN

Metal pens were first manufactured in England at the beginning of the 19th century. Until then, the reed pen and subsequently the quill pen were commonly used. Both were hand crafted and they can still be made much the same way by any calligrapher who has the energy and the desire.

The reed pen is best for larger writing since the material, found in marshland areas and along waterways or purchased in plant stores, is available in a range of sizes. It is a well-suited substance for cutting pens because it has a softer character than the quill.

The quill pen came into gradual use about 190 B.C., possibly at the time when vellum supplanted papyrus as a writing surface. Also, with the establishment of formal Roman capitals, writing required strokes graduating from thick to thin. Flight feathers from geese, swans, and turkeys were suited to quill pens because of their hardness and density. They could be cut into much smaller and finer writing edges than the reed pens, and so were ideally suited to the Roman hand and the vellum surface. Quills can be found at live poultry or turkey farms.

Cutting a Quill. Edward Johnston, in *Writing & Illuminating & Lettering*, offers a detailed description of cutting both reed and quill pens. However, he assumes the reader can purchase a quill pen, partially cut for "ordinary use," at the local stationers (which was true in 1912) and remake it into a more suitable calligraphic instrument.

In *The Calligrapher's Handbook*, William Bishop discusses the preparation of the natural quill from scratch. A quill in its natural state is covered with a greasy membrane on the outside and contains soft pith on the inside. Both of these conditions must be altered—in a process called "clarifying" or "dutching"—before the quill can be cut. Perhaps the easiest of several clarifying methods is to heat the raw quill over an electric hot plate by holding it about 1½ inches (4 cm) above the surface and rotating it evenly for 8 to 10 seconds. The heat softens the quill, shriveling both membrane and pith. Now hold the quill by the feather end and quickly place the barrel on the hot plate itself. Holding a penknife in your other hand, draw the quill repeatedly against the back edge of the knife, rotating the quill after each stroke. Repeat this until you have scraped all the film from the barrel. After it has cooled, polish the quill with a clean, soft, woolen or linen cloth.

Shaping the Nib. The shaping, or nibbing, of both a reed and quill is about the same. The most essential tool is a very sharp knife. There was a time when the quill maker used an instrument designed solely for this purpose; by the 17th century these quill penknives were quite ornate, frequently fitted with handles of gold, silver, agate, or tortoise shell and inlaid with precious stones. The blades were of the finest steel and either fixed into position or made to fold or slide into the handle. With the introduction of the metal nib, the quill knife fell into gradual disuse. Nowadays, a surgical scalpel can be used with success, or use a good steel penknife honed to razor sharpness. With either tool, for best results sharpen the blade on a stone each time you cut a new quill or reed.

Johnston's handbook described six basic steps for cutting and shaping a reed nib:

Cutting and Shaping a Reed Nib

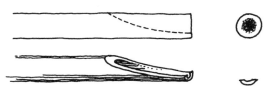

Step 1. Take a reed about eight inches (20 cm) long and cut one end off obliquely. This first cut does not result in a writing edge, leaving a much too rounded portion behind for use.

Step 2. Make a second cut approximately midway into the first cut, shaving smoothly toward the writing end. Keep the knife blade almost flat to the reed, delicately shaving away the soft inside part, leaving the hard outer shell.

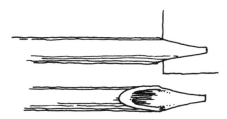

Step 3. Turn the reed over and place it on a slab of hard wood or glass. Hold the knife blade vertically and cut the top off at a right angle to the shaft.

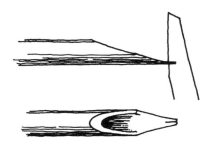

Step 4. Now make a short starter slit into the middle of the tip by inserting the knife edge and pressing slightly inward.

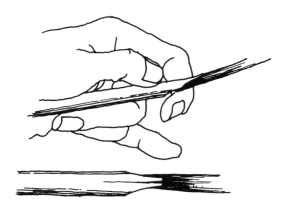

Step 5. Lengthen this slit by holding a pencil or brush handle under the nib while the left thumb presses on top to prevent the slit from splitting too far. Move the handle from side to side and upward until the slit extends to about 3/4 of an inch (19 mm).

Step 6. Return the nib to the cutting slab and trim the tip again at about a 70° angle to the shaft.

Quill cutting is similar to reed cutting, with a few differences. Johnston recommends stripping away the feather filaments or barbs and cutting the shaft to about eight inches (20 cm). The quill is a much harder substance than the reed, so all cuts are correspondingly more difficult and delicate. Sometimes the shoulders—the second cut that determines the actual width of the pen line—must be cut in two strokes, one side at a time, rather than with one bold slice as with the softer reed pen. Cutting the final edge is also a more delicate act. Tilt the blade slightly inward and shave downward slowly, without pressing so hard that you distort the cut. For a very sharp nib, angle the knife even more severely.

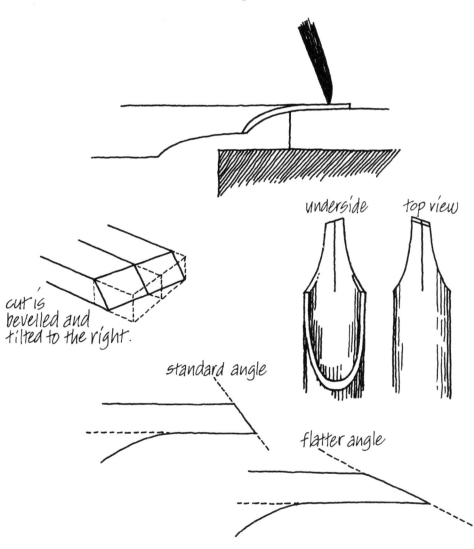

underside

top view

cut is bevelled and tilted to the right.

standard angle

flatter angle

The nib is cut with a very sharp knife at a sloping bevel and angled to the right for right handers. Finer, sharper lines can be drawn if the cut is more flatly angled.

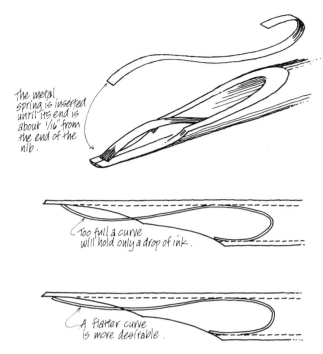

The metal spring is inserted until its end is about 1/16" from the end of the nib.

Too full a curve will hold only a drop of ink.

A flatter curve is more desirable.

shaping and proper placement of reservoir

Making a Reservoir. A reservoir for the reed or quill pen can be made from a strip of thin flexible metal about two inches (5 cm) long cut to the width of the nib. This strip is carefully bent—curved but not creased—into an S-shaped "spring." The larger or bottom loop of this S is then inserted into the barrel underneath the nib. The tension created by slightly compressing the larger loop as it is worked into place in the barrel will hold the reservoir in its desired position. The smaller loop, which holds the ink, should be placed about 1/8 of an inch (3 mm) away from the writing edge in the reed, half that in the quill. This same loop should also be slightly flatter for the quill than required in the reed.

It would not be unreasonable to ask at this point, "Why go to these lengths to make a pen when there is such a broad selection on the market?" It is indeed unlikely you'll come up with a replacement for your favorite metal nib, and it would be very difficult for you to make two pens that would produce identical strokes. (If your Speedball C–1 breaks down in the middle of a project, odds are that its replacement will be more than adequate!) There is, however, a lot of gratification in returning to a "source"—making a writing instrument not unlike one used continuously for centuries. There is also the considerable tactile pleasure of feeling a pen "floating like a feather" across the paper, as well as satisfaction in handling all the materials involved in its making.

RESERVOIRS

Reservoirs, usually made of brass or steel, are attachments designed to hold a larger quantity of writing fluid on the

nib than would be retained through simply dipping the pen in ink. I recommend filling the reservoir with a brush rather than dipping, as this will better control the amount of ink inserted. Too much ink creates too heavy a flow; heavy strokes lose their crispness and fine lines lose their contrast.

A pen will write without a reservoir, of course. It is only a convenience, permitting the calligrapher to write at greater length without having to dip the pen in ink as frequently. Most broad-edge nibs have attached or slip-on reservoirs. Many prepackaged sets of pens contain removable reservoirs as part of the package, while the steel brush incorporates a reservoir in its diamond-shaped design.

Some calligraphers find a top-mounted reservoir a distraction, at times obscuring the direct line of vision to the writing edge. If this is the case for you, consider using the Mitchell Roundhand Series, as the brass reservoir is permanently mounted into the holder and sits underneath the nib. The Speedball "C" Series has a fixed reservoir on top, as does the Pelikan Series, but here the steel reservoir swivels for easier cleaning. The Mitchell Square Cut Series for Italics provides a reservoir to slip on underneath the nib that allows minor adjustments to be made either toward the writing edge or away from it. Unhappily, in this series only one reservoir is included with the 10 nibs in a package.

When buying a pen with an attached reservoir, carefully inspect it to insure that the tip of the reservoir has not been bent away from the nib. This flange should sit lightly on top of the pen with little excessive air space visible when viewed in profile.

CLEANING A PEN

It is a necessary and good practice to clean both pens and reservoirs frequently with a thorough soaking in a solution such as Higgins Pen Cleaner. This comes in a bottle containing a plastic strainer for removing the nibs easily. If the reservoirs are removable, clean them separately in the Higgins cleaner rather than leaving them on the nib. With the Speedball pens a heavy deposit of ink or paint can build up in the reservoir. I will occasionally shave the underside of the brass flange gently with a single-edge razor blade before using the cleaner. This upper flap is quite resilient and if you do not get too exuberant in your scraping, it will spring back into place easily.

I clean a pen continuously, even within the relatively short span of a project, since I often use a waterproof ink that tends to dry quickly. A tiny bit of caked ink can spoil the flow and cause a ragged stroke. To prevent this, I keep a container of water on my taboret and I regularly dip the pen, shake out the excess water, and soak up the remaining moisture with absorbent tissue. Lastly I wipe the pen with a small piece of chamois and check the writing edge closely to make sure it is free of any lint or other foreign substance.

PEN HOLDERS

Because it is such a simple device, the importance of a holder is often overlooked. Prepackaged pens frequently include a holder, but this does not mean it is either the best or the only holder suitable for those nibs. Some holders can accommodate nibs from different manufacturers if the nib shanks are of the

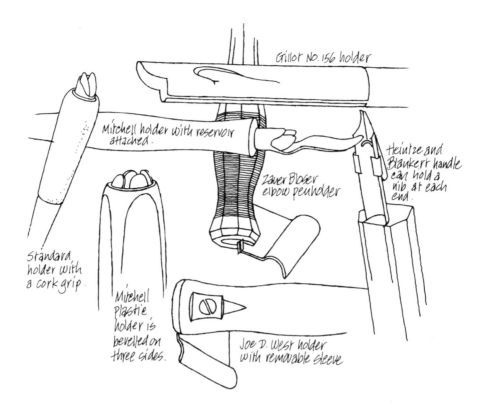

Gillot No. 156 holder

Mitchell holder with reservoir attached.

Zaner Bloser elbow penholder

Heintze and Blankert handle can hold a nib at each end.

Standard holder with a cork grip.

Mitchell plastic holder is bevelled on three sides.

Joe D. West holder with removable sleeve

same size and curvature. Others hold pens that are smaller or for special uses, such as the crow-quill, which has a cylindrical barrel and requires a circular opening in the holder.

There are only two major considerations in buying any pen holder. One is the mechanism that holds the nib in place, and this can be an arching slit, a metal insert, or something more complicated (for example with the Gillot No. 156). The second factor is the barrel or handle—its weight and gripping surface, as well as its girth. A very smooth plastic material can get slippery with prolonged use, causing increased tension in the hand. Some calligraphers favor handles wrapped with cork or grooved rubber where the fingers grip the barrel. Depending on the size of your hand and the firmness of your grip, the weight and circumference of the shaft is very important. It is, of course, a matter of personal preference. A tennis player may choose a very light racquet, but the grip will be commensurate with his hand size. At the same time, a racquet may feel "head heavy" or "head light" depending on the distribution of weight through the head, throat, and handle. Similarly, some calligraphers prefer to have a more delicate holder in order to feel the action of the nib better, creating more of a "head heavy" sensation. Conversely, a bulkier handle gives a feeling of lightness in stroking and the impression of less friction between the writing edge and the surface. Choose the pen holder most comfortable for you that produces the best results.

TYPES OF HOLDERS

Holders are made of wood or plastic, usually combined with metal fittings. The Heintze and Blanckert handle is a simple piece of unpainted wood about five inches (12.7 cm) long. It is flat on one side, and the other sides are beveled into several planes running its length. Half-round slits are inscribed in each end, enabling this small handle to hold two nibs at once. There are no metal fittings at all.

The Mitchell plastic holder packaged with their Italic Series has a four-leaf metal insert in one end of the handle, which is beveled into a triangular form. While comfortable to the grip at first, the nib must be properly located and centered *after* the grip has been established. If the nib is inserted first, additional adjustments must be made once the thumb and index fingers have taken their positions on the triangular handle.

The Zaner Bloser elbow pen holder is a comfortably shaped plastic holder with an angled metal sleeve that holds a straight nib for Copperplate lettering. Perhaps even more functional is the Joe D. West holder, which has interchangeable sleeves to accommodate a variety of nib shank dimensions. A separate holder from the same manufacturer is designed with a sleeve for crow-quill pens.

The Pelikan nibs can only be used in conjunction with their own holder, which is a handsome but complicated affair that requires simultaneously slipping small metal tongues and hooks located on the nibs into tiny openings in the barrel sleeve.

Koh-i-noor of Germany offers several pen holders that are functional and attractive. One is a slim black shaft with a simple metal insert. Another has a bulkier wooden handle, rust orange or black in color, and is trimmed at its grip end with a brass ferrule. This is my sentimental favorite, as it is identical to one issued me in third grade, over 40 years ago!

The Gillot No. 156 is a slim cylinder of black wood with a steel tube attached that has two small wings punched slightly inward to hold the nib.

EVALUATING A HOLDER

When buying a pen holder, it is wise to try it out by gripping the handle in your normal writing posture. Evaluate it for weight and "feel" when a test nib is fully inserted. Then make sure the pen-gripping device is tightly fitted to the handle. The last thing you want is a wobble in the middle of a stroke because of a shaky fitting! Finally, take the time to assess the alignment of the nib to the holder. The nib should sit perfectly straight, forming a direct vertical line from its tip through to the end of the holder. I find it very distracting if the nib is positioned even slightly off center.

Holders are, for the most part, reasonably priced. Buy several different ones to accommodate changing moods and physical demands.

THE FOUNTAIN PEN

The primary advantage of the fountain pen over the nib-and-holder combination is its obvious ability to hold a larger ink supply. There are, however, disadvantages. Fountain pens do not seem to produce the same crisp strokes dip pens do. The nibs have size limitations as well, the largest being no more than 1/16 of an inch (1.6 mm) wide. Their inability to use permanent, waterproof inks without eventual damage to the writing mechanism is also a factor. Nonethe-

pen. Only enough ink to serve your immediate needs should be mixed at one time, since it dries quickly and cannot be stored. In classical Chinese brush writing, this calm interlude when the inkstick was being ground against the stone surface was used by the calligrapher to meditate and prepare mentally and spiritually for the demanding craft of beautiful writing.

COLORED AND METALLIC INKS

These inks are difficult to use because of their inconsistency. Colored inks are virtually transparent—translucent at best—and extremely thin, causing them to run too freely from the pen. If work is being done on a slanted surface, a colored ink will collect at the bottom edge of each stroke, creating an uneven effect. This effect can also be used by intent, but it does increase the hazard of running and smearing. There is also the possibility of losing the thin strokes with colored inks because of the pigment's tendency to be "loose" and collect in one area of the letter, leaving the thin strokes nearly invisible.

I much prefer paint for color work, such as the Pelikan Series of designer's colors (I prefer bottles, for their general convenience, rather than tubes). These need to be thinned with water until the proper flow is established, but not thinned to the point where opacity is lost. Paint dries quickly and the pen nib should be cleaned frequently by rinsing in warm water to maintain a consistent flow.

Metallic inks are extremely difficult to use in penwork. The problem lies in the nature of the writing solution itself, which is metal dust held suspended in a liquid medium. There is a tendency for the metal particles to separate from the vehicle and settle to the bottom of the container. The ink must be blended thoroughly before each use to get any color consistency. Both inks and paints dry quickly, which frequently clogs the pen. I prefer using metallic paint rather than ink, and the Pelikan brand is as workable as any. I store these bottles of gold, silver, and bronze upside down, which simplifies mixing later. These paints can be thinned with water, but take care not to water them down to the point where they run freely from the pen. I tend to be very selective in the use of metallic paints, saving them primarily for such touches as accent letters, outlines, and border decorations. I generally also retouch these areas using a small round sable brush. This adds more gold, silver, or bronze particles and creates a higher luster than can be laid down with one stroke of the pen.

PAPERS

The invention of paper is generally credited to Ts'ai Lun, a member of the Imperial Guard of the Chinese Emperor, in the year A.D. 105, who mixed shreds of mulberry bark and rags with water, beat it into pulp, and left it to dry in the sun. Paper was gradually introduced into other areas of the Orient before making its way to the Middle East. It was not until A.D. 751 that paper was made in Samarkand, the first place outside the Orient to discover the secrets of the craft (from Chinese prisoners of war). Over 400 years elapsed before there is historical mention of papermaking in Europe—a mill established in the Spanish city of Xativa in 1150.

The first instance of papermaking in Italy took place in Bologna in the year 1293, although there is recorded mention of the Fabriano mills as early as 1276. Perhaps the earliest paper mill in

France was established in the Saint-Julien region near Troyes in 1348. The first recorded *use* of paper in England is dated 1309, but it was not until 1495 that John Tate started the first mill in Hertfordshire.

The introduction of paper to Europe was followed by the construction of paper mills in various countries, but this did not mean it was widely available or even accepted. The invention of movable type along with the production of the Gutenberg Bible in 1456 provided the greatest impetus for the use and manufacture of paper in Europe. The Renaissance provided the second influence, as its quest for knowledge demanded a vast quantity of manuscripts and books.

Vellum, made from the skins of calves, goats, and sheep, and parchment, made from the inner side of split sheepskin, were the favored and most majestic of writing materials of the time. Their use was limited, however, by the need to handcraft these materials and, as a result, their price was justifiably high. Paper, until Nicholas-Louis Robert of France invented the paper-making machine in 1798, was also a hand process: individual sheets were made by dipping a mould into a pulp mixture. Nonetheless, this process was faster and less costly than the more tedious effort of making animal skins into vellum and parchment. While both of these extraordinary materials are still available today, the art of papermaking, both by hand and machine, has developed to such a high level of achievement that using skins should be saved for only the grandest of documents.

PAPER QUALITY

A paper that is designated "handmade" implies quality, but by no means should this be an automatic assumption. It is only an indication of the method of manufacture, not the quality of the ingredients. A machine-made wood-pulp paper is suitable for mass-produced newspapers and magazines, but if durability is critical then a paper with a high or 100% "rag" content is preferable. The finest papers are made from choice linen or cotton rags. The rags are macerated and beaten with care and suspended in a vat of pure water. Chemicals are only sparingly used, if at all. The best paper is pH neutral (neither too acid nor too alkaline).

There is no reason a machine cannot produce paper of the same lasting quality as the best handmade papers. If there is any advantage of one production method over the other, it is in the toughness of the handmade product as well as in its esthetic look and feel. Forming sheets of paper with a hand-held mould calls for a four-way shaking process that causes the fibers to cross and intertwine, resulting in uniform strength. A machine is limited to a side-to-side shake, throwing the fibers in one direction only. Machine-made papers therefore have a "grain" and are more easily torn in one direction than the other, whereas handmade papers resist tearing from all directions.

Durability is a desirable quality in any paper, but to the calligrapher the writing surface is even more important. When a sheet of paper has been removed from the mould and dried it is highly absorbent, much like a blotter. To make the surface able to receive ink without soaking it up into a formless blob, the paper is passed through a warm bath of sizing, a gelatinous solution that lightly coats the surfaces of both sides. (Unsized paper is called "waterleaf.") The final step in making paper suitable for

writing is to "finish" the surface (paper comes in a wide variety of finishes, from rough, usually used for watercolor, to very smooth, which is better for writing or drawing). In the early history of papermaking this was accomplished by hand burnishing with agate or smooth stones. This laborious method was later supplanted by the water-powered glazing hammer. Eventually this unwieldy instrument gave way to the Dutch invention in which paper was passed between two large rollers cut from the solid trunk of a tree. Today finishing is accomplished by placing a number of sheets between highly polished zinc plates and running this through heavy metal rollers. Both the amount of sizing and the degree of finish are controllable conditions and are determined by the ultimate use of paper.

PAPERS FOR CALLIGRAPHY

In choosing paper, the calligrapher should first decide how it is to be used and what conditions will affect that choice. If the work is to be reproduced by a printer, then small errors usually can be covered with white paint; a 100% rag paper of great durability would not be needed here. However, if it is one-of-a-kind art, then a long-fibered rag paper should be selected, as much for its ability to withstand corrections by razor blade, erasures, and burnishing as for its lasting qualities.

In warming up for a lettering project, I use a 16-(60 gm/m²) or 20-pound (75 gm/m²) ledger bond paper. This stock is sufficiently sized for reasonably crisp penwork and has a rather nice tooth. It is also translucent enough to use for overlay work when a rough design needs to be reworked and corrected.

For all-purpose lettering, I favor a 100% rag bristol board. It is commonly available from both the Strathmore and Bainbridge companies in 19 × 25 inch (48.3 × 63.5 cm) sheets, and in thicknesses designated as "plys" ranging from one through five, with five being the thickest. (The most common paper designation is based on weight per ream. A ream is a regulation 480 sheets according to Webster, but sometimes has 472 of drawing or handmade sheets, 500 sheets of news or book paper, and a printer's "perfect ream" has 516 sheets. A sheet of 90-pound (340 gm/m²) art paper, therefore, would indicate that a ream of 472 full sheets would weigh 90 pounds (40.9 kg). Bristol board comes in two finishes, "kid" and "plate." The first has more tooth than the second. Of these two surface textures, kid is preferable since the very smooth plate finish can cause problems in stroke control. Many calligraphers, in fact, will use the "wrong" side of kid-finished bristol as it is just a little less toothy. The "rightness" or "wrongness" to paper sides can be established by the embossed seal placed in the corner by the manufacturer or by the watermark in a handmade sheet. The side on which this seal or watermark can be read is the manufacturer's recommended "right" side.

There is an abundance of handmade rag papers available on the market today, representing such fine European paper houses as Arches, Whatman, Wookey Hole, Barcham Green and Co., and Fabriano, as well as such American mills as HMP (John and Kathleen Koller) and Twinrocker (Howard and Kathryn Clark). The choice can be difficult since many of these papers are made for other purposes, such as printmaking or watercolor, even though they may look suitable. The feel of pen on paper is the final test, of course, and will tell you more about the

surface than any touch by hand. Until any writing is done, the purchase of quality stock should be determined by rag content, tooth or texture, weight, and, to a degree, color. (Color refers to the quality of whiteness in paper. A brilliant blue-white cast indicates the use of chemical bleaching agents, whereas handmade papers made without chemicals will have a warm off-white appearance.) It should also be kept in mind that a deckled edge— that frayed border naturally formed in handmade papers by the moist fibrous pulp running against the frame or "deckle" of the mould—is not, by itself, a reliable indicator of handmade paper. Some machines are capable of producing this effect to satisfy those casual consumers interested in paper snobbery.

Finally, there are a variety of papers advertised by their manufacturers as "made for calligraphy." For the most part they are prepackaged, either in pad form or boxed as stationary with matching envelopes. In both cases, unless both rag content and weight are indicated, it is unlikely the paper is suited for anything other than casual correspondence or informal social invitations. Mock or imitation parchment, available in pad form and cut sheets, is an attempt to duplicate the color and surface character of true parchment. A more white, mottled, "snowflake parchment" in the same line is also available. I do not recommend either for serious calligraphy.

STUDIO EQUIPMENT

The beginner in calligraphy soon happily discovers that the cost of basic writing materials, as well as space needs for practice, is quite modest. A starter set of pens, inks, and paper can be purchased for less than $10 and work space can simply be the table in a breakfast alcove. It is only after the calligrapher becomes more involved, by expanding interest or the demands of a budding professional service, that his inventory of materials must broaden and the need for space becomes more critical. Minimal needs for the most basic studio might include the following equipment:

BASIC NEEDS

Drawing Board. A simple drawing board, no smaller than 20 × 26 inches (50.8 × 66 cm), is fine to start with. This board should have a metal strip (called a true edge) attached to the left side so your T square can be properly aligned and ride smoothly. Equally suitable, although more expensive, is a portable drawing board that comes with an attached parallel rule (more about this instrument later), a carrying handle, and folding legs under the top edge. These legs serve to elevate the board, tilting it upward about three inches (7.6 cm), which provides a better, although less than adequate, working angle.

T Square. A T square is essential and is used in combination with the left-hand edge (for right handers) to initially true your paper and to subsequently enable you to draw horizontal lines exactly parallel to each other. It can be made of wood, plastic, aluminum, or stainless steel. Some T squares have adjustable heads controlled by set screws that allow the blade to be rotated and secured at angles off the horizontal. Perhaps the most serviceable T square is one with a plastic blade and a transparent lip as it allows greater visibility and control along the blade length. Unfortunately, this model has an edge that is

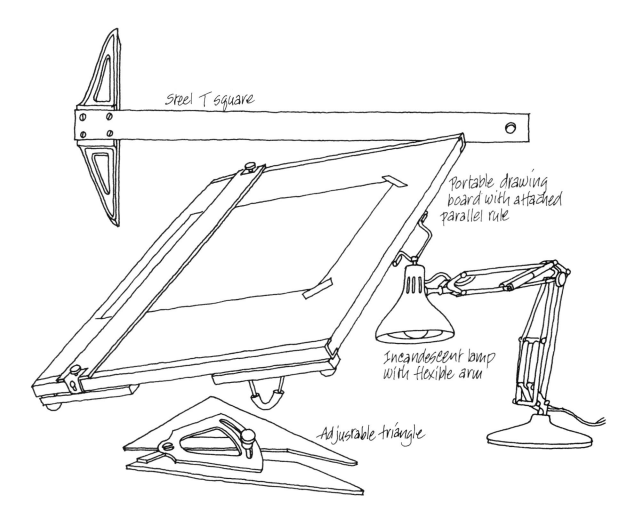

steel T square

Portable drawing board with attached parallel rule

Incandescent lamp with flexible arm

Adjustable triangle

cut flush to the board surface and creates the possibility of smearing when inking lines. This problem can be alleviated by applying a few strips of masking tape the length of the T square along its underside, which raises it off the surface of the board slightly. The stainless-steel unit is beveled along its edge to avoid this hazard; furthermore, it can also function as a strong straight edge for cutting purposes. T squares also come in varying lengths, but no matter which model is chosen it should not extend beyond the width of the drawing board. A 24-inch (61 cm) T square is the right size for the 20 × 26 inch board, for example.

Triangles. These tools are available in clear plastic or a highly visible fluorescent pink and are used for drawing vertical and diagonal lines in conjunction with the T square or parallel rule. They can be purchased in several sizes. One 6-inch (15.2 cm) and one 12-inch (30.4 cm) should cover most calligraphic needs. Only two types of triangles are required by the beginner—one has 30°, 60°, and 90° angles, the other has 45°, 45°, and 90° angles.

PROFESSIONAL NEEDS
The requirements of a professional calligrapher are no more than extensions and refinements of the basic tools and

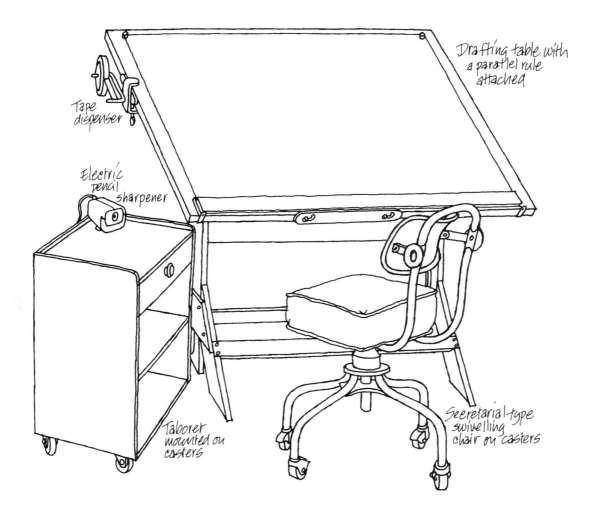

Tape dispenser

Drafting table with a parallel rule attached

Electric pencil sharpener

Taboret mounted on casters

Secretarial-type swivelling chair on casters

equipment needed by the beginner, plus a few new items.

Drafting Table. These tables come in a great variety of sizes and can be constructed of wood, plastic, metal, or combinations of these materials. The primary difference and advantage of the table over the simple drawing board lies in the fact that it is a table, with either hardwood support legs or a cast-iron base. The top is usually equipped with a tilting mechanism and adjustments that can elevate or lower the entire surface. A relatively modest table with these controls in the 31 × 42 inch (78.7 × 106.6 cm) size is a good buy. It should

have a true edge and a retaining strip of wood or metal at the bottom edge to keep unattached material from slipping off the tilted surface.

Table Top Cover. The writing surface of a table should be kept free of scratches, pin holes, and indentations of any type. It is advisable, therefore, to cover the board with a protective material. Art stores that carry a line of drafting supplies usually stock vinyl sheets made just for this purpose. Pale green on one side and ivory on the other, they are designed to minimize glare and eyestrain as well. This covering can be cut to size and adhered with double-face tape.

sitting on the table. The basic unit usually consists of a container fitted with a cylindrical piece of sandpaper that is covered by a cap rotating on a central pivot. Allowing the lead to protrude from the holder about a half inch (1.3 cm), insert it into the tubular opening on the sharpener's cap. Now rotate cap and pencil until the lead is sharp (the sandpaper-covered cylinder inside will be bringing the lead to a point).

Drafting Instruments. In addition to the techniques of lettering, calligraphy is a craft that frequently calls for considerable precision. A working knowledge of mechanical tools, therefore, can greatly assist the calligrapher in preparing his work before the actual lettering process begins.

One can buy very elaborate drafting instruments, of course, but there is no need to acquire a comprehensive set of these tools. A ruling compass with an interchangeable head to hold a graphite point, a beam attachment, a ruling pen, and a pair of dividers should be sufficient. Both the ruling pen and ruling compass are used to draw precise ink lines of uniform width or ink borders to outline an area that can then be easily filled in with a pointed sable brush. The beam attachment to the compass, with either lead or ruling pen affixed, is used to draw circles or arcs exceeding the maximum radius of the compass by itself. A divider is an instrument similar to the compass, having two prongs that are used to accurately gauge the distance between two points. This measurement can then be transferred to another area without remeasuring, or even knowing, its exact dimension in inches or centimeters. Dividers can also be used to step off equal spaces along a line with ease and precision.

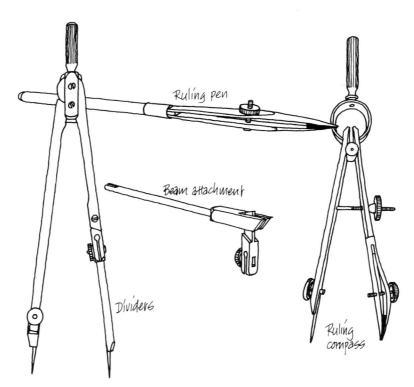

Ruling pen

Beam attachment

Dividers

Ruling compass

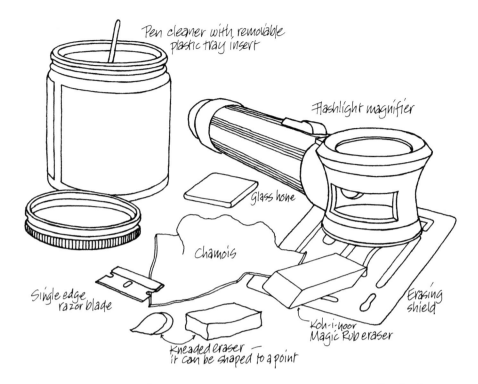

Pen cleaner with removable plastic tray insert

Flashlight magnifier

Glass hone

Chamois

Single edge razor blade

Kneaded eraser — it can be shaped to a point

Koh-i-noor Magic Rub eraser

Erasing shield

Storage Unit. For storing and protecting both finished artwork and fresh paper, I use a steel, five-drawer, flat cabinet, 38 × 50 inches (96.5 × 127 cm) in size. Each drawer is two inches (5.1 cm) deep. Although your cabinet need not be this large, its purpose is to permit you to store papers flat and away from light and dust.

Erasers. Buy both a kneaded eraser, made of soft, malleable rubber that can be shaped to a point, and a harder rubber eraser, such as the Koh-i-noor Magic Rub, for heavy-duty work.

Erasing Shield. This metal or plastic template is used to mask off and protect those areas not intended to be erased.

Pen Cleaner. Higgins Cleaner is a bottled solution in which nibs can be immersed and soaked. A perforated plastic disk with an attached handle is fitted into the bottom of the bottle for convenient removal of the pens. Denatured alcohol can also be used to soften encrusted waterproof inks on nibs.

Chamois. A small piece of lintless doeskin is very useful for pen wiping.

Magnifying Flashlight. I use this for close inspection of the tines and writing edges of my nibs. It can also be used to check paper surfaces and erasures.

Glass Hone. This small piece of finely textured glass, about two inches (5.1 cm) square, is used for delicate honing, such as removing the burr from recalcitrant nibs.

Razor Blades. Have several single-edge blades on hand for making delicate corrections by scraping inked areas. These blades are also handy for gentle cleaning of encrusted nibs.

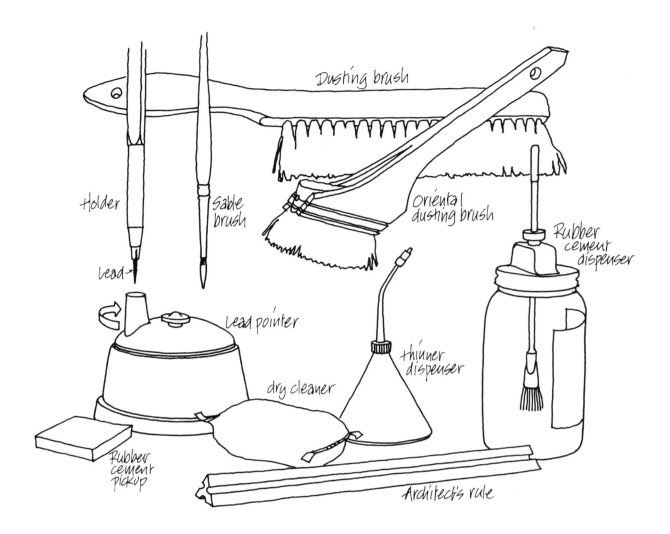

Brushes. A small, rounded No. 3 sable brush can be used to fill nib reservoirs with ink or paint. A smaller No. 1 brush is convenient for delicate retouching and whiting out areas in work done for reproduction.

Dusting Brush. This flat, wide brush is used for general housekeeping chores around and on the drafting table. I also use a small, finer haired Japanese brush to dust work in progress.

Dry Cleaner. This powdered substance is most suited for lightly cleaning large areas. It is contained in a sturdy cloth pouch that is squeezed to bring the abrasive substance to the cloth surface. The entire hand-held bag is then rubbed gently over the paper surface. I have also found this cleaner handy in removing the high gloss from very smooth papers, adding just enough texture to the surface for the pen to bite. After this cleaner has been used, the paper must

be swept thoroughly clean with the dusting brush to remove the very fine granules before any additional work can be done.

Rulers. For accurate measurements I prefer the architect's rule. This is a triangular piece of wood or plastic on which measurements are inscribed in several calibrations. The advantage of this rule is that it is cut sharp and flat and will lie flush to the paper, permitting more precise pencil markings.

Masking Tape and Dispenser. Use masking tape to "tack" down your work to the drawing board. A handy dispenser can be purchased as an attachment to the edge of the board. I prefer the white drafting tape over the buff-colored masking tape, more as a matter of esthetics than better performance. However, masking tape also has a greater tendency to damage the paper as it's being removed.

Rubber Cement and Thinner. This is the only adhesive the artist should use to paste up mechanicals for reproduction. It is very versatile and allows a margin of error. Misaligned work can be peeled off and relocated. Buy a medium-size can of both cement and thinner and transfer a smaller amount of each to separate dispensers. The brown glass bottle or opaque plastic bottle, both with a built-in brush attached to the cover, is the cement dispenser. Thinner, which is used to dilute the adhesive to a light, workable consistency, should be kept in the small metal dispenser that resembles an oil can. This is also handy for squirting pure thinner underneath the edge of work for easier removal.

Rubber Cement Pickup. This small rectangular piece of tough plastic is used to pick up excess rubber cement; it can be cut and shaped to an edge or point to get into and clean small crevices.

Nine Lettering Styles

THE NINE CALLIGRAPHIC hands in this chapter have been selected from many historic forms so you can see and compare basic alphabets. Each has a distinct flavor and character, formed when it was invented by historical influences, the needs of the time, occasionally materials (the size and availability of skins, for example, affected the cramped quality of Gothic Blackletter), and finally the hand of the scribe. The effort of the scribe to attain greater writing fluency and quicker movement of the quill across the writing surface frequently resulted in reshaping the strokes and ultimately altered the letterform itself.

This is probably a good moment to remind you how important it is to strictly follow the basic form of any alphabet, at least until you attain a firm base of technical competence. There is time enough to be creative, and personal style will develop naturally from continued practice. As a professional watercolorist I have admired many outstanding painters and occasionally emulated one, but have always found that true comfort, ease, and confidence developed only from continuous work. Those personal characteristics that will eventually identify your artwork will rise naturally from persistent practice and performance.

LETTER ANATOMY

Letters have "anatomical" parts and you should be familiar with the terms used to describe them. The larger and first classification of any letter is whether it is a *majuscule* (a capital letter) or *minuscule* (a small or lower-case letter). Thereafter, letters are broken down into these components:

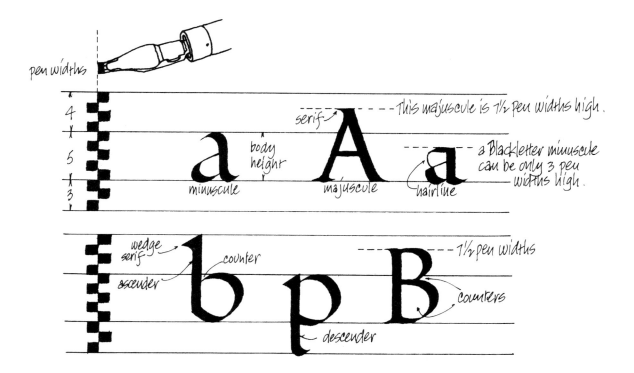

Body. The portion of a minuscule letter that does not include ascenders and descenders and can be contained between two parallel guidelines.

Ascender. A stroke that rises off the body of a letter and extends *above* the top guideline.

Descender. A stroke from the body of a letter that drops *below* the bottom guideline.

Serif. A thin line stroke appearing usually at the end of and at an angle to a major stroke.

Counter. The portion of a letter that is open *space*, not occupied by a stroke. It can be enclosed, semi-enclosed, or open, large or small, and is vital in establishing letterform.

Hairline. Most apparent in Gothic Blackletter, it is a fine-line continuation of a stroke for both decoration and to help fill a large counter area.

The vertical proportion of a letter is determined by the width of the pen nib. This "system," as such, is quite flexible and can be manipulated within esthetic limits. The pen is used to make small, horizontal notations representing the full width of the nib, along a vertical line, imaginary or penciled in. A standard proportion would be four–five–three, a total of 12 marks. The top four marks indicate the space allowed for ascenders, the five middle marks the body of the letter, and the bottom three the length of the descenders. This method, therefore, automatically means using a four-guideline system, whereas the Uncial alphabet, with its modest ascenders and descenders, would only need two guidelines.

A B C D E

F G H I J

K L M N

> MODERN UNCIAL IS A MAJUSCULE ALPHABET
WITH INDICATIONS OF "ASCENDERS" AND "DESCENDERS."

O P Q R

S T U V

W X Y Z

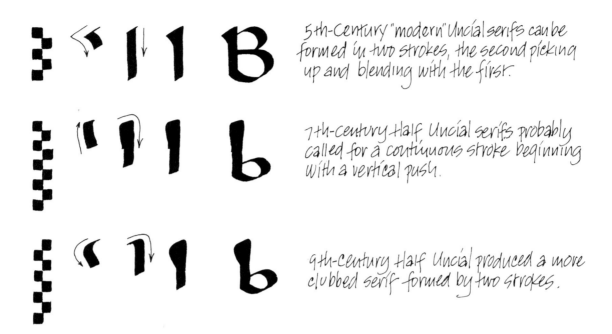

5th-century "modern" Uncial serifs can be formed in two strokes, the second picking up and blending with the first.

7th-century Half Uncial serifs probably called for a continuous stroke beginning with a vertical push.

9th-century Half Uncial produced a more clubbed serif formed by two strokes.

HALF UNCIAL

There is some confusion in the origin of the Half Uncial letter. Some paleographers theorize that it developed as a natural outgrowth of the Uncial alphabet. In any case it does seem to be a logical and forward step in the history of letters. It is still a majuscule alphabet, but with such distinctive strokes above and below the two guidelines that it could easily be mistaken for minuscules. Reading it in its original form would require some acquaintanceship since these were capitals that appeared to be small letters. It underscores, perhaps, the significance of the dual alphabet (having both majuscules and minuscules), which was not to appear until the 13th century.

At first glance, the Half Uncial letter will look curiously squashed and writing it will seem difficult. With greater familiarity, however, the form becomes quite regal and dignified. It is not, of course, meant to be a fast hand, especially not in the sense of Italic writing,

but its evolution is attributed to a desire for greater speed, and this resulted in rounded corners, tighter curves, and a greater thrust to the now very evident ascenders and descenders.

Characteristics. Ascenders are clubbed, perhaps as an acknowledgment to the Roman serif. They were originally formed with a vertical push stroke before turning downward. The body is compressed, with the looped letters suggesting an old-time football (not quite a pointed oval). The s is curious and needs repeated practice before it appears well integrated in a word. It evolved from the classic Roman S, which required three separate strokes to form. This s requires one continuous movement that finishes with a strong, upward thrust. Writing this letter quickly will help explain why its height is almost equal to the ascenders in this alphabet. It also reminds us that the Half Uncial requires generous interlinear spacing.

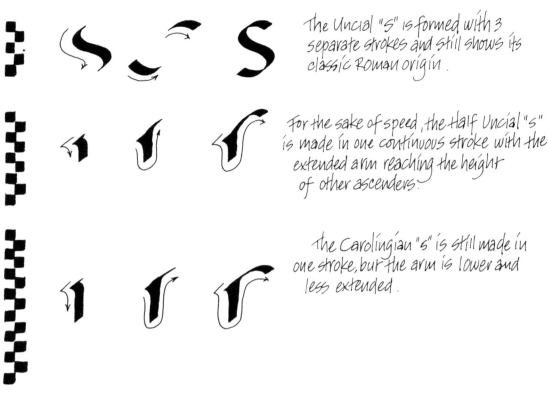

The Uncial "S" is formed with 3 separate strokes and still shows its classic Roman origin.

For the sake of speed, the Half Uncial "s" is made in one continuous stroke with the extended arm reaching the height of other ascenders.

The Carolingian "s" is still made in one stroke, but the arm is lower and less extended.

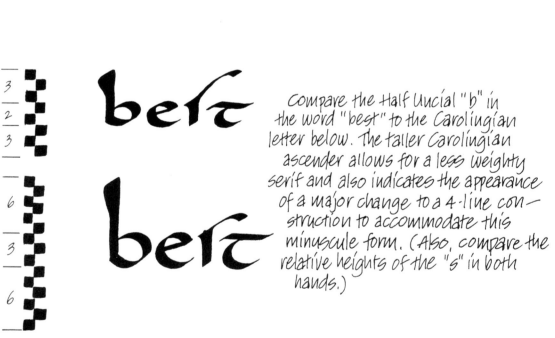

Compare the Half Uncial "b" in the word "best" to the Carolingian letter below. The taller Carolingian ascender allows for a less weighty serif and also indicates the appearance of a major change to a 4-line construction to accommodate this minuscule form. (Also, compare the relative heights of the "s" in both hands.)

a b c d e f ʒ
h ı j k l m n

half uncıal appears to be a lower-case hand

but ıs, ın fact, a majuscule alphabet. ıt ıs wrıtten

wıth very large spacıng between lınes and a

body heıght of only two pen wıdths. the feelıng

of the page ıs open and majestıc.

o p q r s t u
v w x y z

ABCDE
FGHIJK
LMNO
PQRSTU
VWXYZ

versals are designed initials

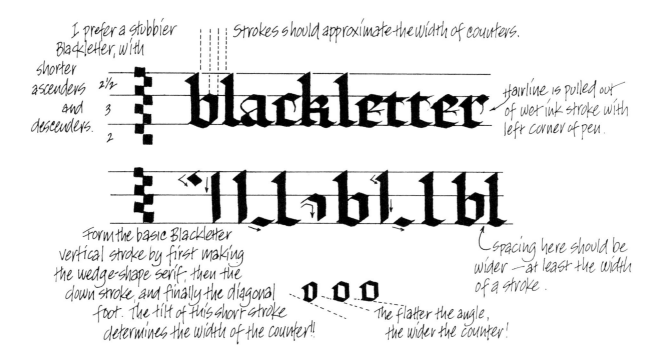

I prefer a stubbier Blackletter, with shorter ascenders and descenders.

2½
3
2

Strokes should approximate the width of counters.

blackletter

Hairline is pulled out of wet ink stroke with left corner of pen.

Form the basic Blackletter vertical stroke by first making the wedge-shape serif, then the down stroke, and finally the diagonal foot. The tilt of this short stroke determines the width of the counter!!

Spacing here should be wider — at least the width of a stroke.

The flatter the angle, the wider the counter!

GOTHIC OR BLACKLETTER

Blackletter superseded Carolingian around the 12th century, flourished for 300 years, and gave us the first capital alphabet that could be combined with minuscule forms. Its evolution was a reflection of the Gothic spirit exemplified by architecture, as well as the more mundane but very real restriction imposed by the scarcity of parchment and vellum. By condensing space in and between letters, and "justifying" borders—or attempting to keep the left/right margins even in a block of writing—a large amount of material could fit into a comparatively small area. Speed was also a factor, although to the untutored eye the letters might seem extremely difficult. By closing up counters and equalizing space between letters, the hand and eye develop a rhythm that almost eliminates the need for a conscious attempt at spacing. Strokes, for the most part, are verticals of uniform thickness, evenly paced, with serifs resembling thick wedges.

Characteristics. The pen is held at a 30° angle, with the stroke width establishing the relationship between it and the space of counters. The space between letters is in proportion to the space within letters, creating a very even distribution of white to black areas. Since so many of the minuscule Gothic letters have at least one straight side, it is relatively easy to control the placement of one letter next to the other. Only the opensided c, r, and perhaps the e, f, t, and z suggest the need for planning ahead in letterspacing. Interlinear space is tight, due both to the shorter ascenders and descenders and the desire for greater density. The use of the four–five–three

HUMANIST BOOKHAND

Italy saw a great revival of interest in Roman antiquity during the 15th century. Carolingian was rediscovered in the mistaken belief that it was an ancient Roman hand because so many manuscripts had been found. Of course it was Charlemagne who, 600 years earlier, had insisted Carolingian become the standard alphabet, and in the process had many ancient Roman documents recopied. The scholars of this Renaissance period adapted Carolingian to their own needs, modifying the form. With paper available in quantity and in large sizes, they were able to expand letters, vary counters, and generally develop a more open letterform, comfortable for both eye and hand. Its familiar appearance to us today is testimony to the durability of the Humanist hand. The invention of the printing press in 1450 by Gutenberg eventually led to many type forms that evolved from the formal hand of the Italian scribes and are still evident in much of our current printed material.

Characteristics. Writing the Humanist Bookhand should be a pleasant, almost familiar experience. The letters are gracefully formed. The strokes logically develop the thick and thin characteristics from the pen held at a fixed 30° slant. Spacing between letters requires planning because of the generous counters. Space between lines is full without being as open as in the Carolingian hand. Bookhand is extremely legible and size does not affect its clarity. The hand is unobtrusive and of such classic demeanor that it could ideally function as the cornerstone in your repertory of letters.

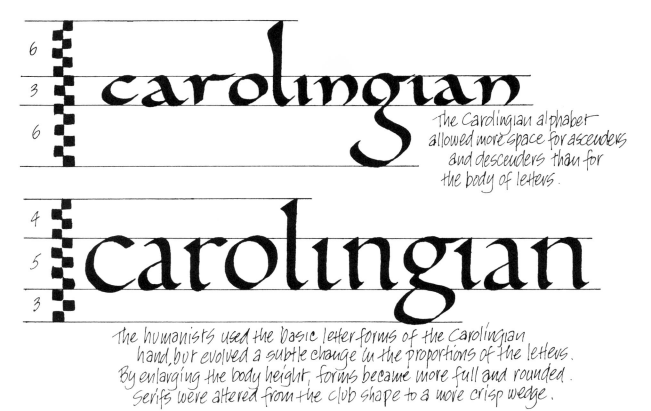

6
3
6

carolingian

The Carolingian alphabet allowed more space for ascenders and descenders than for the body of letters.

4
5
3

Carolingian

The humanists used the basic letter forms of the Carolingian hand, but evolved a subtle change in the proportions of the letters. By enlarging the body height, forms became more full and rounded. Serifs were altered from the club shape to a more crisp wedge.

a b c d e f

Humanist Bookhand
is a comfortable alphabet for both
hand and eye and will maintain its
warmth and legibility no matter how
large or small it is written.

g h i j k l m

n o p q r s t

u v w x y z

ITALIC OR CHANCERY CURSIVE

Humanist Bookhand was an outgrowth of the Renaissance when Italian scholars, in their exuberance for ancient Rome, rediscovered Carolingian. The discovery of the formal and serene Humanist hand is attributed to Poggio Bracciolini, but the Italic form is credited to Nicolo Niccoli. Chancery Cursive, an ornate version of Italic, takes its name from the Papal Chancery's endorsement, in the 15th century, of its use in writing papal briefs. Cursive simply describes any writing that is linked by connecting strokes between letters. Italics, in its current context, describes slanted writing that has connectives and is of sufficient clarity and simplicity that it can be appropriately used for writing of an everyday nature. Chancery Cursive, however, is a more flourished style, which is particularly noticeable in its capital alphabet, and it should be used more discriminately.

Characteristics. To write Italics, two basic angles must be observed. The broad-edge pen makes contact with the writing surface at 45° to the horizontal, but the slant of the letters is only 10° off the vertical. This is a very modest tilt to the right, and beginning students will frequently exaggerate this angle. The result is letters with disproportionate thicks and thins.

The nature of Italics, or any running script, lies in the way letters are joined. Linking letters, using push as well as

Italic joins are effected through the use of either diagonal or horizontal strokes.

pulling strokes, and minimizing pen-lifts are all pronounced characteristics of Italic writing. Theoretically the more directly one letter is joined to the next, the faster the hand can be written. However, it is not that simple in practice. Not all letters can be gracefully linked together, nor should you force a join where it cannot be unobtrusive. The two most commonly used joins are the horizontal and diagonal strokes. The first instance is heavy in appearance, for example linking the crossbar of an *f* to the beginning of an *o*. The second connective is the diagonal hairline stroke from the end of a letter, such as the *a*, moving at a 45° slant upward into the beginning stroke of perhaps an *i*. I rarely use the horizontal join, feeling its heaviness is awkward and distracting. I prefer isolating the letter for clarity and visual rhythm.

In choosing between the modern Italic form and Chancery Cursive, I tend to let function dictate form. For casual, social communication, where communication is the main consideration, the unfettered Italic is clear and direct. I use Chancery Cursive for manuscripts where the contents have more meaning and the rich flourishes will add impact. Finally, the Italic hand is perhaps the only style that can serve both roles without requiring drastic departures from the basic form. It is also flexible enough to allow personal character to surface, again without significant changes in the classic Roman hand.

calligraphy

calligraphy

I prefer using the more ornate Chancery Cursive with few if any connectives.

ABCDEFGHIJK LMNOPQRSTU VWXYZ

Keep in mind the difference between the tilt of the letter, which is 10° off the vertical, and the pen angle maintained at 45° to the horizontal.

abcdefghijklmnopq rstuvwxyz &

1234567890

The "old style" numbers, with "ascenders" and "descenders", combine well with minuscules, as in: 315 Riverside Drive 10025

1234567890

Numbers of uniform size are more appropriate with majuscules, as in: 77 CHAMBERS ST. 10007

COPPERPLATE OR ROUNDHAND

Copperplate, as you know, was not a hand evolved from Roman origins. Its kinship is to the copperplate engraver and it became popular after the invention of the printing press. It was, in fact, the active competition between scribe and engraver that necessitated the scribe's exchanging the broad-edge quill for the pointed nib in an attempt to emulate and exceed the fine scratchings of the engraver's burin. However, in order to draw the thick "swells" from that same nib, pressure had to be applied on the down movement, which would spread the point and increase and broaden the ink flow. This was a laborious effort in contrast to the ease of using a chiseled pen. It became painfully necessary for the Copperplate scribe to make a conscious effort to ma-nipulate the pen and acquire a new rhythm of alternating pressures.

It was mentioned earlier that the Italic hand slants at 10° off the vertical. By contrast, Roundhand is written at 36° off center, or 54° measured from the horizontal. This extreme tilt became popular in the late 18th and early 19th centuries and resulted in the invention of the oblique pen holder to facilitate writing at this angle. An oblique nib was developed later, but never achieved the popularity of the holder.

Characteristics. Copperplate is distinguished by its extreme slant and even appearance. When done well, there is a surprising sense of a freely written script. The lines from each letter flow gracefully from and into each other and the swells appear effortless. A strong

Copperplate is written at a slant of 54° with a pointed nib and develops its form from hairlines combined with pressure strokes called shades and swells.

lateral movement is accentuated by tall, squared-off ascenders and descenders. The capitals are very ornate and given to generous swirls, which to the naive eye seem ideal for extra embellishment. This, however, is not the case. Copperplate is strongly structured and any attempts at added flourishes must be well planned before pen is put to paper. The abuse of Copperplate, I suspect, has something to do with the difficulty of the technique. The steep pen angle, the use of contrasting hairlines against the pressure strokes for swells and shades, the number of penlifts required, and the flexible, pointed nib itself are problems the student must overcome. There is, in addition, a restriction on the maximum size of Roundhand, since a pointed pen can only make a swell as large as the flexibility of the nib will permit. In the face of all these obstacles, once the calligrapher acquires some Copperplate facility, it is almost understandable that he might want to "showcase" his abilities with unneeded embellishments. George Bickham's *Universal Penman*, a collection of engravings, shows fine examples of both the excessive and the controlled hand.

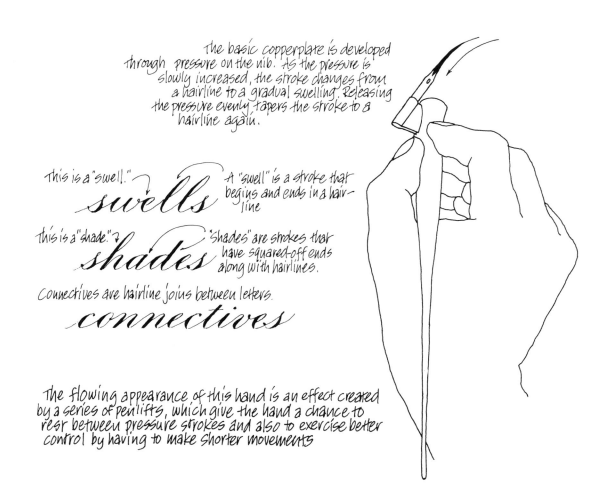

The basic copperplate is developed through pressure on the nib. As the pressure is slowly increased, the stroke changes from a hairline to a gradual swelling. Releasing the pressure evenly tapers the stroke to a hairline again.

this is a "swell." *swells* A "swell" is a stroke that begins and ends in a hairline

this is a "shade." *shades* "shades" are strokes that have squared-off ends along with hairlines.

Connectives are hairline joins between letters. *connectives*

The flowing appearance of this hand is an effect created by a series of pen lifts, which give the hand a chance to rest between pressure strokes and also to exercise better control by having to make shorter movements

space, proportion, color, visual density, decoration. All these aspects must be creatively organized into an esthetically pleasing image and it is the awareness of these design ingredients that ultimately separates the Ming vase from the utilitarian pot.

SELECTING THE
APPROPRIATE STYLE

Should we use the Copperplate hand to announce a garage sale? Is the modern Uncial alphabet appropriate for a shoe advertisement? What is it we look for in a letter style that would make it suitable in one instance and totally inappropriate for another?

A Special Garage Sale!

Hand-lettered Copperplate, or English Roundhand as it is sometimes called, was not always an uncommon hand. At the height of its popularity in the late 19th and early 20th centuries (before the typewriter), it was taught in English elementary schools and used as a professional hand by bookkeepers. Over the years, however, its application has become more selective and it is now identified with specific occasions. In machine-printed matter, for example, Copperplate is most often seen on wedding announcements and invitations; when hand lettered, it can be found on envelopes with formal enclosures, place cards for formal dinners, or graphic material for events of a similar nature. It has, rightly or wrongly, become associated with occasions of "significance," or it is used to confer "richness" or

"class" on the subject. It is even used occasionally in advertising merely to upgrade the image of a product or business concern. The answer, therefore, to the question of whether to use this hand to announce a garage sale would be an emphatic "no."

Mr. and Mrs. Dennis C. Weeks
request
the pleasure of your company

Our instinctive response to the second question, using modern Uncial for a shoe ad, might also be "no," but on further reflection it could well be "yes." For modern Uncial is a warm, dignified alphabet that is considerably more flexible than Copperplate. If our product is a designer's shoe, or simply one of good craftsmanship and quality materials, then Uncial might well be appropriate.

FLORENTINO
FOOTWEAR

Exercise 1. There is an interesting exercise I play with my students that any calligrapher can benefit from trying. Write down one-word adjectives describing your reaction to a particular letter style—both your positive and negative feelings. If Gothic Blackletter is under consideration, for example, the list might include words such as "dignified," "ornate," "decorative," "unread-

Blackletter

ORNATE

PONDEROUS

DECORATIVE

UNREADABLE

INFLEXIBLE

DIGNIFIED

Develop a sensitivity
for letterforms and
their appropriate use
by trying to assess
their character and then
applying it to different
situations and purposes.

WEDDING INVITATION

TRANSMISSION SERVICE

HOLIDAY GREETINGS

SKI EQUIPMENT

TRAVEL AD

MENU

Exercise 2.

peter pan

charlemagne

Beethoven

JULIUS CAESAR

Eisenhower

Frederick Wong

ROBIN HOOD

Consider my solutions to Exercise 2 but, by all means, try combinations of your own.

a b c d e f g h i j k l
m n o p q r s t u v w x
y z

Copperplate or Round-
hand is a script form
written at a severe
angle with an oblique
nib or a straight pen with
an elbow holder.

1 2 3 4 5 6 7 8 9 0

A B C D E F G H I J
K L M N O P Q R S T
U V W X Y Z & V W

Letter Design

THE PRECEDING CHAPTERS show that calligraphy is a technique and a craft with historic beginnings developed from the need to communicate. Using pictures to describe events, abstracting these literal representations to make relevant symbols, developing and refining the alphabet with symbols representing sounds, and, finally, developing more sophisticated writing instruments and grounds, all represented progress in the history of letters and evolution in the beauty of the written form.

We are currently experiencing enthusiastic interest in calligraphy. Historic letterforms, refined through centuries of use, are available for us to study. An abundance of well-constructed, economical writing tools and a variety of well-made papers permit us to practice and develop a fluent and confident hand. But after technique has been learned and the process of making well-formed letters is second nature, the calligrapher must look toward a new aspiration. The most essential goal is to learn how best to apply calligraphic art to practical situations.

A lump of raw clay in the hands of a potter can be formed into a simple vessel or into a Ming vase. Both are utilitarian objects, but the first is purely functional. The other is also functional, but it goes a step beyond: it is a thing of beauty, an art form. To write with clarity and beauty may be an end in itself, but it can also be more than that. As the master artisan manipulates the clay into wondrous form, the scribe can apply his skills to the two-dimensional expressions of his talent.

Any project to which we bring our calligraphic abilities must include design considerations and decisions: the choice of hands, the distribution of

able," "ponderous," or "inflexible." Then draw up a list of products or events and apply your descriptions to each. Why might Blackletter be appropriate or inappropriate? The object of this exercise is to realize that it is the scribe's responsibility to select the lettering style appropriate to the task at hand. In fact, the success of any calligraphic endeavor may well lie in the ability to choose, with sensitivity, a letter style that will create an esthetically congenial relationship with its subject matter. Furthermore, you must be able to explain your design choices to your client, who quite often is unable to make such esthetic decisions.

Exercise 2. Another exercise my more advanced students enjoy is matching a large variety of hands to an equal list of interesting people. A sample list might be as follows:

Half Uncial	Robin Hood
Carolingian	Your name
Blackletter	Julius Caesar
Roman Majuscules	Peter Pan
Bookhand	Charlemagne
Italic	Beethoven
Versal	Eisenhower

The only conditions I impose are that all the hands must be used and no hand may be used more than once. You might begin by considering that the use of your name only implies you are a living, contemporary person and therefore the choice of alphabet should not be a graphic representation of your personality or fantasies. The next stage of the exercise is to actually write out the list of names in the letter style you have deemed most appropriate. In my classes these are put up on a bulletin board for a period of open critique. The students learn there is no perfect solution to the problem that is completely satisfying to everyone. However, they are also made verbally and visually aware of the reasons for selecting and using a hand judiciously.

My own matchups, as seen in the illustration, are probably also open to question. However, given the choice of names and hands, they do represent my best attempt to evaluate the spirit of an alphabet and link it to the image of a particular person.

I began with my own name and chose Italic because it seemed the most contemporary. The tilt of the letters also suggested motion or action, which is very much a modern-day characteristic. The next two matchups seemed obvious. Historical fact ties Charlemagne to the Carolingian hand, as does Roman Majuscule to Julius Caesar (although Bookhand, because of its flexibility and dignity, was a near choice). I chose to use that alphabet for Eisenhower instead to encompass qualities such as steadiness, reliability, and firmness. Versal letters seemed very appropriate for Robin Hood because, remembering my childhood reading experiences, these forms are inextricably bound to the illustrated book plates of many types of adventure stories. Finally, the rich, dense Blackletter was used for Beethoven, as much an acknowledgment of his Teutonic heritage as musical qualities. Half Uncial for Peter Pan was a revelation for me, as it was really the result of a process of elimination. At first the hand's rich, archaic feeling, more suited for religious and ceremonial documents, seemed a bad choice. However, after it was written out the letterforms looked light and whimsical and just right for the spirit of Peter Pan.

Peter Pan

JULIUS CAESAR

I would deem these two combinations of lettering style and personality inappropriate.

The trial-and-error attempts at combinations by my students provided us with as much insight into the appropriateness of letters as the most successful examples. Blackletter was obviously too ponderous for Peter Pan, although Versal and Carolingian did not seem ill-fitting. Versal letters, with their generous swells and fine hairlines, seemed too lively for Julius Caesar, who required dignity and stateliness. It appeared, therefore, the exercise was equally well illustrated by those examples that paired the two elements awkwardly.

THE ALPHABET

How any person reacts to a given letter style is, of course, subjective. But there is a common denominator for all calligraphers and that is our alphabet. Developed over the course of thousands of years, painted, chiseled, imprinted, and written, the historical forms we practice today carry the undeniable force of traditional use. Some hands virtually dictate their use; others are more flexible and will permit manipulation, although not abuse. The classic Roman capitals of the Trajan Column are only Roman capitals if they maintain their exact proportions. But the formal Roman Bookhand is an alphabet of great versatility. The Italic hand, used for papal pronouncements in the 15th century, has managed to survive hundreds of years intact and pure, and is the favorite lettering style today. What calligraphers are confronted with now, therefore, is the need to recognize the commonality of the various hands and the strength of their historical images, and, within this context, make choices based on our abilities to use them in contemporary settings. The distinction between a modern page of lettering and a broadside of a hundred years ago is not contingent on the need to redesign or "invent" a hand, but on the skillful application and adaptation of classic forms to the spirit and needs of today's images.

USING THE SINGLE MAJUSCULE

Once the hand has been chosen for a calligraphic project, the next concern is for the artist to determine how to esthetically enhance or augment the basic forms to bring a more pleasing richness to the project. One area that offers this opportunity is the majuscule. Body text does not offer much flexibility, as readability is usually primary. Beyond the occasional ascender flourish or the swash stroke at the finish of a letter, not too much inventiveness is possible or, I

You are cordially invited to attend....
Our Best Wishes this Christmas Season
Announcing our One-Day Sale....!

You are cordially invited to attend....
Our Best Wishes this Christmas Season
Announcing our One-Day Sale....!

These two classic hands are comfortably adaptable for contemporary statements.

believe, needed. The capital letters, however, can be an important and exciting design element.

At one time the capital letter was the only letterform used by scribes. All the now-familiar hands—from Roman through the Half Uncial and until the rise of Carolingian—were used as text forms to write complete manuscripts. This did not change until the Gothic period and the appearance of the dual alphabet.

The most significant application of the single majuscule began with the consistent use of Versal letters and, of course, with the onset of Carolingian minuscules. It should be remembered here that the earliest books consisted of continuous lines of capital letters, with no breaks for words, sentences, or paragraphs. Eventually, as functional separations developed out of need, slight indentations were incorporated to mark the beginning of a new thought or para-

graph. Finally, letters were pulled from the text and used for decoration or simply to start the eye moving in the reading direction. This was ordinarily the first letter of the first line, written larger and away from the text into the margin. Carolingian minuscules, with their unmistakable ascenders and descenders, made a strong visual departure from the earlier majuscule forms; by the late 11th century, square Roman capitals, Uncials, and occasionally Rustica letters were used to begin a verse. The acceptance of this practice led to the development of Versal letters, which in time generated the first dual alphabet, a complete set of capital letters designed to work solely with the Gothic minuscules. Eventually these Versal letters became design elements in their own right, reaching their most highly decorated form in the Gothic period as illuminated letters, richly colored and embellished with gold leaf.

EARLIEST WRITINGS CONSISTED
ENTIRELY OF MAJUSCULES WITHOUT
PUNCTUATION MARKS WORD SEPAR
ATIONS SENTENCE BREAKS OR PARA
GRAPHS AND COULD WELL HAVE TAKE
NON THIS APPEARANCE

Earliest manuscripts were written in lines of continuous majuscules without breaks.

Beginnings of paragraphs can catch the eye with the use of an enlarged versal letter.

The use of the enlarged versal letter was for both functional and decorative purposes.

This example of an ornate illuminated Versal letter was freely copied from Edward Johnston's "Writing & Illuminating & Lettering."

The use of the decorative single majuscule is very much in evidence today. In editorial material, the enlarged capital letter, either set in type or hand lettered, is used as a line, paragraph, or chapter lead-in. One also sees the majuscule used in areas of graphic design. The National Broadcasting Company, for instance, uses the designed *N* for corporate identity. Although not calligraphically lettered, it does represent single majuscule application. There is no reason why any capital letter cannot be treated as a design element, restructured and directed toward a specific modern-day design need.

Single majuscule lead-ins to paragraphs of text are frequently used in typography.

ALTERING THE FORM

We isolate a majuscule to single it out. By doing so the letter's basic form is altered: through enlargement, the addition of color, decoration, or a combination of these. The form of the letter can also be subtly exaggerated, just so long as it does not represent a departure from the text hand, that is, completely unrelated in spirit and form. When there is a need to redesign a letter substantially, it is best to practice first using a broad, chiseled marker—a modern tool that requires no dipping and produces quick-drying strokes in uncommonly large widths. These practice images should be as close in size to the final rendering as possible so the eye can accurately judge proportion and the balance of counters. Enlarging a letterform affects not only its relationship to text material and its impact on the total page, but also the letter itself. Remember, too, there is a degree of enlargement that even the broadest of pens cannot easily accommodate in a single stroke. It then becomes more advisable to contend with the problem either as a constructed form to be outlined and filled in with a brush, or by using a photostatic enlargement (see Chapter 8, *Production Methods*).

These are large practice majuscules drawn with a broad, chiselled edge marker.

A large, chiselled marker is a very convenient modern tool to use for practicing enlarged majuscule forms. The ink is quick drying and the marker, of course, requires no dipping.

Extremely large forms can be produced photostatically and then subsequently traced, outlined, and filled in with a brush.

MULTI-MAJUSCULES

At some point in the history of letters majuscules were combined into a single design unit. Yasaburo Kuwayama suggests, in *Trade Marks & Symbols*, that it may have been as far back as 4000 B.C. as potters' marks were found on articles excavated from the area of Corinth in Greece. Identification symbols for craftsmen have been historically evident for thousands of years, and with the expansion of Mediterranean trade in the fifth and fourth centuries B.C., commercial enterprises began to mark their goods with symbols of ownership. With the rise of the guild system in the 14th century, these small design units were used to identify and separate the producer—the metalworker, weaver, lampmaker, brewer—from the trader or the seller of the goods.

With the development of the alphabet, of course, it became evident that letters as well as symbols could be effectively used for identification. With the invention of the printing press and use of movable type in the 15th century, we have an even greater use of letters along with symbols in trademarks.

In calligraphy, combining more than one majuscule into a single design is called either a monogram or a cipher. While the distinction is subtle, there is a difference. A. A. Turbayne, in *Monograms and Ciphers*, defines it this way: "A Monogram is a combination of two or more letters, in which one letter forms part of another and cannot be separated from the whole. A Cipher is merely an interlacing or placing together of two or more letters, being in no way dependent for their parts on

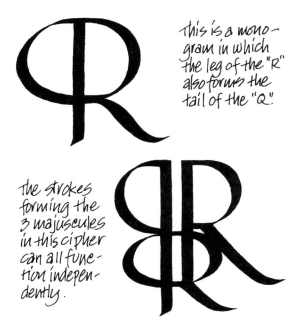

this is a mono-
gram in which
the leg of the "R"
also forms the
tail of the "Q."

the strokes
forming the
3 majuscules
in this cipher
can all func-
tion indepen-
dently.

This familiar
cipher is the
logo of the New
York yankee
baseball team.

By overlapping
the strokes of
the "N" with the
arms of the "Y,"
this symbol now
becomes a mono-
gram.

other of the letters." These designs are marks of ownership and are used primarily for identification or ornamentation. On a personal level, they can be seen engraved into silverware, on social stationery, embroidered into shirts, worked into leather book bindings, and, more rarely, carved into furniture.

The contemporary term, which includes monograms, ciphers, the single majuscule, as well as the designed minuscule, is *logo*, which comes from the word logotype. A familiar example of a logo, which is in actual fact a cipher, is the combined majuscules, *N* and *Y*, used to identify the New York Yankees baseball team.

Logos are very much a part of our graphic environment today. It is a business in itself within the graphic design field, and corporations spend an enormous amount of money and effort to achieve a symbol that will best identify their service or product. Frequently the logo will be a totally abstract symbol, showing only subtle hints of its representational source. Just as often, the logo will use corporate initials (several capitals designed and juxtaposed in shape and color) to create a precise and compact image that will ultimately be repeated over and over again in a variety of media on a multitude of surfaces.

It is rare to see hand lettering used in major logo design today. The corporate image is more traditionally served by letterforms derived from type, with the block letter, at least for the time being, seemingly favored over styles that have serifs. This situation is undoubtedly a part of our 20th-century machine esthetic and is evident in all areas of both two- and three-dimensional design. Calligraphy is still used, however, as the basis for forms that are then constructed with mechanical tools rather

than hand written. The department store Saks Fifth Avenue has a logo that, although spelled out in full, very much reflects its Copperplate origins.

The calligrapher's hand is also apparent in logo design areas less broad in scope, such as letterheads, business cards, book plates. These are generally associated with smaller, perhaps more personal, enterprises. A further assumption is that calligraphy, by its very nature, can best serve a purpose that will reflect its "humanity" and accept the subtle variations of the human hand, "warts" and all.

DECORATING MAJUSCULES

The greater the departure from the basic form of an isolated majuscule (or majuscules) the less readable the letter becomes. The most legible letter, of course, is the traditional form, pure, undecorated, and unfettered by extraneous matter within or around the strokes. As the calligrapher begins to manipulate the form and the space around it, the letter will become less and less distinct. The question then is, "How meaningful is the readability of that letter, either on its own terms or in terms of the adjoining text?" If, for instance, the project is a ceremonial certificate, then ornamental richness is probably quite apt and the lead capital should be richly decorated. I would only caution you to exercise control of your design, so the majuscule does not become overly expansive or distract from the overall design.

Exercise. In decorating a majuscule there are two major areas to consider: the letter strokes themselves and the spaces within and around the letter. Let us first see how strokes can be enhanced by using the Versal *P* as an example. The decorated majuscule is usually a built-up letter rather than stroked because of its size and ornamentation, so first pencil it in lightly, several inches high (about 10 cm), to give you some working room. Start with the hairline serif at the top of the vertical stroke and increase its width to 1/16th of an inch (1.6 mm). Use this dimension to outline the entire letter. You now have a Versal *P* that has become an open letter—one in which the outline gives the letter significance, rather than the solid, filled-in form.

The open areas within the strokes can be further decorated with color or lines or patterns. The outline of the letter itself, having been given a thickness, can also be manipulated. It can be thought of as a rope or length of brass wire that can be twisted or interwoven into a pattern at selected junctures within the vertical bar or at the widest point of the loop. To further enhance the strokes, the leg of the *P* can be extended down to accommodate more body text and the loop enlarged proportionately.

To complete this decorated majuscule, the background—the area behind and around the letter—should also show some decoration. It should, of course, be related in character and appearance to the letter. Draw a border around the *P* to define the amount and shape of the space to be decorated. This border also has a thickness, but should be narrower than the measurement used to create the open *P*. It should also be geometric rather than follow the configuration of the letter. Remember to also keep it appropriate in size and contour to the other elements on the page. This enclosure can now be filled with color or selected motifs that are in harmony with those decorating the letter.

I have described this exercise as a series of steps, but keep in mind that

successful design is not a process in which elements are separately considered and then somehow fitted together. Rather, design is a total consideration and the elements should be developed simultaneously to create a unified whole. Finally, as your designs become more complex and your alternatives greater, remember that your creative impulses must be guided so you do not reach the point where ornamentation becomes excessive and self defeating.

The final rendering of this majuscule includes darkening the background, which heightens the three-dimensional quality of the letter.

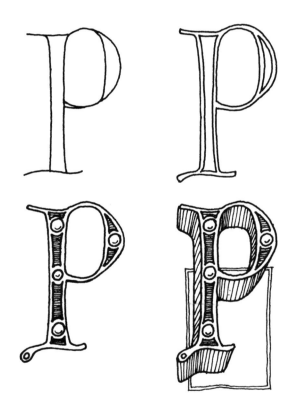

These four units illustrate one way in which a versal "P" is progressively changed from a simple two-dimensional outline form to a more ornate image having the appearance of bulk and thickness.

counters

THE AWARENESS OF COUNTERS

A "counter" is an enclosed or semi-enclosed space within a letter. This space is an essential consideration in establishing the quality of balance. It can also be called "negative space" (an expression more frequently heard in drawing and painting studios), which for us means that area in the structure of a letter not occupied by a stroke. A counter can directly affect the proportions of a letter and, as discussed further in the next chapter, the placement of one letter next to the other.

Exercise. The eye and hand experience solid forms more readily than negative space. It is only when a letter does not appear "right" that we realize a stroke has been misplaced and the balance of the letter altered. Lower the crossbar of a Roman *A* and you will sense an immediate difference from its classic definition. What you have actually done is shifted the volume and weight of white space to the enclosed triangle at the top and diminished the space below the crossbar. Also consider the Roman majuscule *E*. When you raise or lower the center stroke it quite obviously changes the balance and hence the character of the letter. Evaluating these displacements, we would probably say, "The center bar is too low, or too high." In effect, we are also saying the upper counter is either too large or too small. Reading counters and anticipating them as one writes a sequence of letters is, happily, an acquired instinct that becomes second nature with the continual practice of calligraphy.

By shifting the cross-bar in the Roman "A" we can readily appreciate the precision of its classic placement. Again, consider the change in the counters as the bar is shifted.

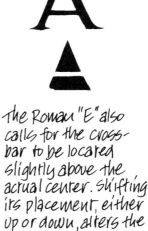

The Roman "E" also calls for the cross-bar to be located slightly above the actual center. Shifting its placement, either up or down, alters the character of the letter.

LETTER DESIGN

Counters, along with other subtle aspects, determine the character of any letter. The weight and angle of strokes, the size and shape of serifs, and the overall dimensions of a letter are all problems awaiting the designer for solution. Those of us who have practiced the historical letterforms for many years and have become proficient will, on occasion, amuse ourselves by trying to design new letters based on the old hands. It is then that we learn to appreciate both the logic and rightness of the classic forms. It is not immensely difficult to produce a single letter that is both readable and esthetically pleasing. The problem is to devise and maintain a consistent character throughout a dual alphabet. Then the challenge is to allow these letters to be combined into words and sentences and still project a uniform image.

The pursuit of new letterforms is more evident in typography than in hand-written letters. Frederic W. Goudy, in *The Alphabet and Elements of Lettering*, describes the problem of type design this way: "The test which a well-formed letter must meet is, that nothing in it shall present the appearance of being an afterthought—that every detail shall at least seem to have been foreseen from the start; and, when letters are used in combinations to form words and sentences, that no one of them shall stand out from its fellows or draw attention to itself at the expense of those with which it is associated."

Words & Lines

IDEALLY, the art of calligraphy encompasses the study of its history: its crude beginnings and its development into an alphabet, as well as the invention and adaptation of tools and materials, especially the printing press and the typewriter. It is a fact-gathering process from which insights are gained and a sensitivity to the letterform is developed.

The practice of calligraphy, however, is a matter of acquiring technique. It is the craft of writing letters beautifully, which demands an awareness of their many subtle nuances. Using a broad-edge pen to write a single letter, or even a series of isolated letters, is a process that can be easily taught. It is a greater challenge, however, to take the next step, to esthetically place one letter next to another to form a complete word. For here we must discuss not only form, but the absence of form—space.

LETTER AND WORD SPACING

If words were composed of a series of identical letters—an unlikely event—our problems with spacing would be negligible. The amount of space between letters could be determined mathematically, rather than through the considerably more difficult process of esthetic judgment.

Our alphabet is a series of 26 symbols, each representing a different sound. This means each symbol or letter must be recognizably individual in appearance and unlike any other. Thus, when writing we are continually confronted with the problem of placing dissimilar forms side by side. Happily, there are three rules of thumb that help simplify these letter-spacing decisions:

1. The *greatest* distance should be allowed between two straight strokes.

2. The *next largest* space should fall between a straight and curved stroke.

3. The *least* distance is required between two curved strokes.

Exercise. A good illustration of these three conditions can be seen by writing the word "doodle." There are five separations contained in this word. First write the word and make all the letter spaces measurably equal. The most obvious error is in the space between the *d* and the *l*. The other four spaces are less disturbing to the eye, but nonetheless need adjustment, as we can see once the *d–l* relationship has been corrected. The closeness of the first four letters only serves to emphasize the now more generous gap between the *d* and the *l*. To actually balance the entire word, an attempt to visually adjust the spacing must be made between *all* the letters. Using our three rules as a guide, we can break down the problem into three component parts. Space considerations between the *d* and *o*, the *o* and *d*, and the *l* and *e*, are covered by rule No. 2, with rule No. 1 applying to the *d–l* relationship and rule No. 2 solving the *o–o* combination. It should also be noted that adjusting one pair of letters (the most obvious illustration being again the *d–l* relationship) will superficially enhance the appearance of the word, but on critical inspection it will be evident that without making space accommodations between all the letters, "doodle" looks like "dood le."

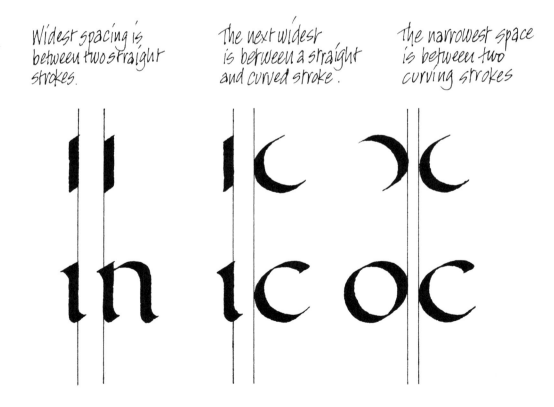

Widest spacing is between two straight strokes.

The next widest is between a straight and curved stroke.

The narrowest space is between two curving strokes

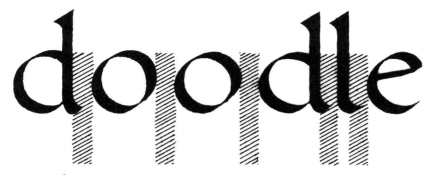

These five spaces are measurably equal. The most noticeable error is between the two vertical strokes of the "d" and "l."

The "d-l" spacing has been adjusted wider, but the other four spaces remain equal, giving the word the appearance of being too spread out.

narrowest → | | ← widest

Spacing has been adjusted throughout, the word creating a more balanced image.

ITALIC SPACING

In the Italic hand, where many letters can be joined for greater speed and rhythm, good spacing would appear to be more easily achieved. Nonetheless, the three rules still apply and with an additional subtlety. When two straight-sided letters are joined, for example, more space should be allowed than if the same two letters are not joined. Italic connectives are either horizontal or diagonal; in both cases, if space is not allowed for the linking stroke the coupling will feel cramped. In fact, the diagonal join partly predetermines the amount of space needed.

Exercise. A good example of linked Italic letter spacing is when *i* is linked to *u*. The connective begins at the tail of the *i* and joins the top of the *u*. Since the broad-edge pen is stroked at a 45° angle in the Italic hand, the letter *i* is completed at this angle and the diagonal made at the same angle. If the diagonal is correctly made, with the pen properly positioned at 45°, the only line that can be formed will be thin and uniform and will not thicken until the pen starts its downturn to form the *u*. The space, therefore, evolves automatically.

SPACE

In discussing a design element such as spacing, we cannot avoid inexact terms like "largest" "next largest," "most," and "least" when describing a quantity of space. These terms have meaning

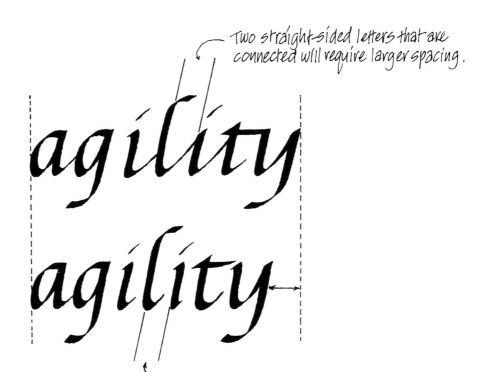

Two straight-sided letters that are connected will require larger spacing.

Straight-sided letters that are not joined can be placed closer together without cramping the word.

90

only in relation to each other, however, and have no fixed definition. When all has been said, it is the scribe's responsibility to assess the spatial relationships in a word and determine their esthetic coherence. Beginners almost invariably place letters too far apart, probably feeling the need to allow a generous amount of space to accommodate the next form. This first impulse also reflects the understandable desire to focus on letter construction. But once the hand is skilled, the eye takes responsibility for spacing and the emphasis in the calligraphic process can shift from letter formation to establishing balance in a sequence of letters.

A series of diagonal joins in a word can cause problems in spacing.

45° 45° 45°

stadium

Diagonal joins are drawn at a 45° angle and determine the space between letters.

iu

iu

Spacing is more flexible when letters are not connected.

COUNTERS

It is important at this point to again raise the subject of counters. The rules I have discussed above are broad based—representing problems that confront all calligraphers—but they offer no solution for placing letters adjacent to counters. In the word "concave," for example, we have six separations, two of which are distinct "counter situations." The two *c*'s contain semi-enclosed spaces; the *e* is similar in construction, but because of its position its effect is on the succeeding word. We also have the *v*, which defines a large open area by virtue of its diagonal construction. Of special note is the combination *c–a*, which contains opposing counters. In this particular letter style—Roman Bookhand—the *a* along with the *s*, *x*, and *z* all have counters on the left side. In addition, the letters *v*, *w*,

Rule #2 covers spacing needs between a straight-sided letter and one having arcing strokes

There are no "rules", as such, determining spacing between straight sides and diagonals, and diagonals and curving strokes.

concave

the counter inside the "c" is a large semi-enclosed space that can only be balanced by the placement of the next letter.

The spacing between these two letters is difficult to control because two counters are being placed face-to-face.

a s x z v w y

The shaded areas in these seven letters represent left-side counters. These large openings are particularly difficult to adjust when placed next to a right-side counter, such as an r-y combination.

and *y* offer left-hand diagonal counters. These seven letters, therefore, can create visual problems when combined with letters containing counters on the right. Returning to our word, "concave," we see a need to close up space between *c* and *o*, due to the large opening in the *c*, and between *c* and *a*.

Exercise. Practice the word "concave" and try making all the required space adjustments. Then reassess the total word by scanning it quickly. Is there any sensation of weight and separation toward the last three letters? If so, it is because three of the first four letters are full, rounded forms that create a feeling of airiness in contrast to the compact sensation of the three remaining letters. To correct this, the *v* and *e* should probably be stepped to the right to distribute the space more evenly.

At first glance, this spacing seems evenly distributed. However, the last 3 letters are more compact than the first 4 and appear bunched together.

concave

concave

These four letters are quite full and enclose large volumes of space.

By shifting these 3 letters slightly to the right — particularly the "v" and "e," there is a better sense of balance throughout the word.

WORD SPACING

Word spacing is based on the assumption that all words in a line are well balanced and have no obvious openings or spaces that will visually conflict with the spacing required between words. Again there is a rule, suggesting that the space between words should approx-imate an *o* from that hand. (In majuscules, a capital *O* would of course be used.) The exception would be when the end of one word and the beginning of the next places two letters with large counters face to face. In this situation, a slight tightening up of the space is advisable.

humanonature
human nature

Ordinarily, an imaginary "o" from the lettering style used will approximate the space required between words. However, there are exceptions. (see below.)

fineoartist
fine artist
fine artist

Using the imaginary "o" between words that end and begin with letters having open counters that face each other allows too much space and should be tightened

THE HEADING AND EMPHASIS

A heading is a word or several words used for focus, emphasis, pure decoration, or, in conjunction with a body of text, as both a lead to the eye and a descriptive statement of the contents of that paragraph or page. In order for words to be visually emphatic, they have to be separated from the main body of reading matter, either by proximity, size, color, form, ornamentation, or combinations of these qualities.

Headings were used beautifully in early documents and manuscripts. In combination with highly rendered majuscules, such headings gave rise to the word "illumination," a reference to the glitter of letters richly ornamented with gold leaf. Apart from the use of the single capital, full words in either Carolingian or other Versal forms were written in a decorative line across the top, occasionally inserted into the middle, and also used at the conclusion of the text. This distribution of emphasis throughout the entire page provided a series of interesting visual breaks and offered momentary relief from the monotony of dense text. While there are a variety of traditional formats for decorative headings in ceremonial documents, it would probably be of interest and benefit for the modern calligrapher to explore some of the more updated possibilities that would still convey the sense of richness and dignity so evident in the early manuscripts.

A heading almost insists it be written at the top, and the name is derived from that natural placement. However, if we choose to think of a heading as simply "relevant words" rather than as an auto-

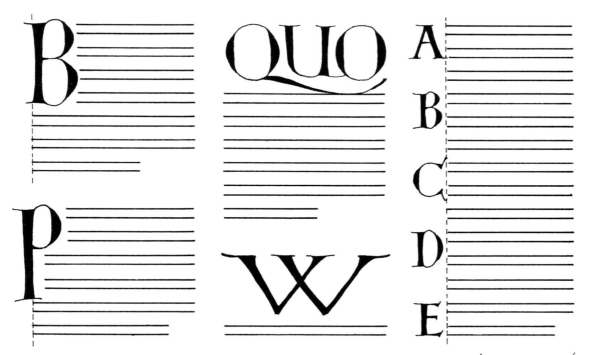

Versal letters are used to introduce a paragraph of text and also function as decorative accents. Entire words and expanded letters can also be used for emphasis.

matic location, we can place a heading anywhere within the confines of our paper, as long as it conveys importance and is consistent with the overall design.

Exercise. If an organization is presenting a *Man of the Year* certificate, the title would be the heading and the critical design unit around which the layout is constructed. The name of the sponsoring agency, text material, and even the name of the recipient become secondary considerations. Given the importance of this accolade, you might instinctively project a very formal design in which all elements are evenly distributed off a vertical center line. This is a very traditional, trustworthy format, probably appropriate for the occasion and doubtlessly acceptable to the client. Nonetheless, a more adventurous approach might also be well received. Instead of a presentation using the verti-

A layout does not have to be centered in order to feel balanced

cal axis, try a horizontal composition with the heading clustered at the left. The name of the "honored guest" can be worked into the copy toward the right-hand border, with the bulk of the text in between. Or this same heading can be placed in the upper-middle of the page, with all the information grouped around it. Many exciting variations come to mind once you depart from the confines of traditional imagery.

For greater visual interest, information can be distributed around a centered heading.

ESTIMATING LINE LENGTH

The length of a line of lettering, whether it is a heading or text, is usually determined by the amount of space the line naturally needs to occupy. Line length is also influenced, however, by the design of the total page and by its relationship with all the requisite elements. An award certificate, for example, might require a logo, official seal, the name of the award, a single line for the recipient, space for official signatures and the date, and the name of the awarding agency. All these elements frequently must be included, and they can take up much of the allotted space even before text or decorative elements such as borders and ornamented majuscules can be considered.

There is no fixed formula by which the length of any written line can be determined. The practiced calligrapher, after choosing a lettering style and the body height, can decide on a line length and quickly establish whether a certain number of words can evenly occupy that area without substantially altering the letterforms or their natural spacing. The trick, of course, is to maintain the character of the style and its readability. There should be no distortion unless the line functions primarily as decoration. As an example, in some ceremonial certificates the word "RESOLUTION" is the required heading, but the text usually opens with a line that begins "Be it resolved. . . ." This essentially repeats the heading and its mean-

The readability of a heading is frequently determined by the space it has to occupy. Smaller letters will require excessive gapping in order to fill the necessary width.

ing. Therefore, the calligrapher has the option of reducing the readability of "RESOLUTION" to make it more decorative. The 10 letters can be strung in a line spaciously across the full width of the text, and the reader will turn to the first line of text for clarity. If, however, the client insists that a title be the focal point and be comfortably readable, then letter spacing and word spacing to fit a fixed dimension must be considered.

Exercise. Assume that an overall layout calls for uniform borders on both sides, with the title, a word such as "RESO-LUTION," centered across the top. The calligrapher must allow the width of the designated area to dictate the size—the height—of the letters. Try using half-inch (1.3 cm) Versals to fill a line 10 inches (25.4 cm) long and you will see that there will be inordinately large spaces between letters. Knowing these same 10 inches must be filled by a single word having 10 letters should now suggest the need to increase the vertical dimension of these letters. Repeat the title, this time using larger letters, and continue until the word fits the space. The reverse is also true. A five-inch (12.7 cm) width would not accommodate one-inch (2.5 cm) letters. These measurements are exaggerated to better illustrate the fact that your eye should be able to make a quick preliminary evaluation of the proportions of letters relative to the space they must occupy.

RESOLUTION

this spacing is decorative but difficult to read.

RESOLUTION

This line is readable and comfortably spaced.

RESOLUTION

The word is readable but the spacing is tight, possibly too cramped for Roman majuscules.

SPACING SENTENCES

A sentence written in a text hand creates a different sort of spacing problem. A sequence of letters forms words, which are in turn linked into a sentence. This obviously engenders many space considerations within the line even before we try to estimate the required line length. My approach is to write the line out freely on a practice sheet using the preferred pen for the hand and size I think appropriate. I make no attempt at fitting the written line into a fixed space, beyond casually eyeballing the width, nor do I use any parallel guidelines. I try not to inhibit the actual writing experience in any way, other than trying to make the sentence appear as esthetically pleasing as possible. Chances are I will not be wildly off and I will have something visually graphic to consider and work with. If I am quite close to the desired width with my first attempt, then I will redo the line. This time I will pay particular attention to letter spacing and try to tighten up (or expand, if the line was too short) minute areas evenly along its length.

Fitting words into a horizontal space involves much more than word spacing and line length. You must also consider the complete, designed page, which may contain many text lines, a heading, lead-ins, and a variety of component parts that all relate to each other and affect the appearance and placement of the words or sentences. As is always the case, practice will substantially shorten this copy-fitting process and ultimately eliminate much of the laborious guesswork.

Try lettering a line "freehand" to fit a predetermined space.

Fill this width with one line of handlettering

Try lettering a line "freehand" to fit a predetermined space.
First attempt at estimating line width "freehand" resulting in one word spilling over into another line

Try lettering a line "freehand" to fit a predetermined spac
Second try between guidelines is closer, with one letter and period extending beyond space

Try lettering a line "freehand" to fit a predetermined space.
Third attempt is well inside space, but line can be extended to fit.

INTERLINEAR SPACING AND LINE BREAKS

In typography, the space between lines of type is referred to as "leading" (pronounced "ledding"), which is obtained by inserting thin metal strips between the lines. When type is set without any leading it is said to be set "solid." As more metal strips are added and lead size increases, the appearance and readability of the text is altered. Too much leading in a block of copy is as unreadable as too little.

Calligraphers must also be aware of interlinear spacing—the space between lines of lettering—and learn how best to use it to their advantage. Imitating the typographer, we can add imaginary leadings to our work to enhance its readability or to convey a feeling of elegance.

The calligrapher's version of setting "solid" is controlled by the length of ascenders and descenders in the alphabet. In a block of copy they should neither touch nor overlap. It is common practice to allow one line to define both the height of the ascender and length of the descender in any two lines. This means that it is possible for two letters to touch (a "p" above an "h," for example) if they should unfortunately align in that position. It would then be necessary to shorten the guilty ascender—and it would have to be the ascender because it would be on the second line of copy—by a hair to avoid the appearance of one continuous vertical spanning two lines of lettering. This adjustment, however, is an unsuccessful solution since the eye would tend to span this tiny gap and read the two strokes as one.

In type, this is called setting "solid—without any leading.

These lines are leaded with a generous space in between.

Type lines cannot overlap, as this sentence demonstrates.

A preferred corrective measure, although much more difficult, is to adjust the spacing within the words, or lines if necessary, so the ascender is shifted in either direction out of alignment.

Some hands, Half Uncial and Carolingian, for example, require much greater space between lines than the bare minimum, as there is a distinct loss of characters and elegance when these hands are compressed. Blackletter, by contrast, is intended to be compact and loses much of its unique appearance when spread too far apart. There are also occasions when ascenders and descenders are deliberately shortened in order to pack lines more closely together, but this should only be done if no other solution is possible.

LINE BREAKS

When writing a quantity of text, the calligrapher develops both a physical rhythm as his hand forms the letters, words, and sentences as well as visual pacing by evenly distributing strokes and spaces. This flow, however, is occasionally interrupted by little-used punctuation marks, such as the colon, semicolon, hyphen, or quotation marks. These line breaks usually occur in the middle of the sentence, although a set of quotation marks can appear at the end. While these marks are small in size, they still call for proper placement and can affect the position of the letter that

Carolingian and half uncial both require very large interlinear spacing, the first calling for at least eight pen widths and the second hand needing a minimum of six.

Carolingian and half uncial both require very large interlinear spacing, the first calling for at least eight pen widths and the second hand needing a minimum of six.

The same nib was used for both these hands, writing the same amount of text material. Only the interlinear spacing and, of course, the character and structure of each lettering style are different.
Carolingian and Blackletter represent, perhaps, the extremes in spacing between lines.

Line breaks are the result of infrequently used punctuation marks: the colon, semi-colon, hyphen, quotation marks, and even the question mark are examples. A word that needs to be separated into syllables at the right-hand margin is the most common example of an interruption to the rhythm a calligrapher establishes in writing a quantity of text. Typographical and typewriter spacing can be used as a frame of reference for punctuation-mark placement.

follows.

The easiest way to resolve these situations is to follow typographical and typewriter practice for both placement and spacing. For example, a colon follows a word directly, occupying the space in this manner: a larger space *follows* the punctuation mark. This is also true of the semicolon and hyphen. Quotation marks are more difficult because they often follow a comma or period that also requires spacing. What helps considerably, however, is the fact that quotation marks sit above the body height of minuscules at majuscule level. This allows tighter spacing than is first evident, but the quotations should not be drawn directly over the comma or period.

Line breaks occur most frequently at the right-hand margin when a word cannot be fully written. When this happens the word should be broken by the syllabic rules in the dictionary, with one note of caution: if the word contains three syllables, it is visually preferable to end a line with one syllable and the hyphen and begin the next line at the left-hand margin with the remaining two. This practice enhances both the readability and appearance of the text.

END-LINE FILLERS AND FINISHERS

Another problem that frequently arises in a mass of lettered lines is the appearance of the unexpected gap, for example when a sentence ends close to the right-hand margin but there is not enough space to start the following sentence. It can also occur at the end of a paragraph or at the conclusion of the entire piece where a much larger, unwanted space is left.

Finishers and fillers are devices that can fill these gaps handsomely if handled with imagination, reason, and restraint. Used to excess, these flourishes and designs can distract the eye and give the faulty area undue importance.

If a gap is modest in size, the terminal stroke of the last letter can be flourished gracefully to fill the area. It should never look obvious or contrived and must stay in character with the hand in use. When a lengthier space needs filling, small dots in designated groupings can be used evenly along the line. These forms should be made with the same pen used for the text and under no circumstances should they betray an emergency effort made to "plug up" holes.

Flourishing of terminal strokes can enhance space if used with discipline.

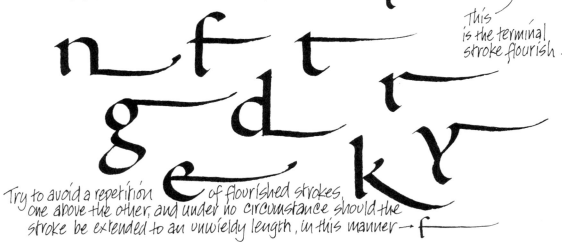

This is the terminal stroke flourish.

Try to avoid a repetition of flourished strokes, one above the other, and under no circumstance should the stroke be extended to an unwieldy length, in this manner → f

Use decorative flourishes and dots to enhance spaces that are awkward.

Exercise restraint!

The Page

FOR WANT OF a better title I have called this chapter *The Page*. I use the word in its broadest meaning, however: any calligraphic project rendered on a two-dimensional surface. This can range from a dinner menu to a wedding invitation, a manuscript page or a ceremonial certificate, as well as any graphic material that can be served by the unique skills of the calligraphic designer. (I should state at this juncture that I regard myself as inseparably both, a calligrapher and a designer.)

This chapter, then, will discuss the graphic elements of the page: layout, copyfitting, illustration, and other aspects of page design.

LAYOUTS AND MARGINS

Any preliminary attempt to compose and organize the elements of a project into a creative whole is called layout. The designer's layout is like an artist's sketch and an architect's blueprint combined: all the basic design elements are placed in their proper position and in scale. There are often many stages to laying out even a simple project.

The first effort, after all the ingredients have been assembled, is to broadly determine how much space the words and other elements will occupy. We are at this moment only concerned with the volume of space the material will fill, not the spacing between units. If the dimensions of the page have been established, make a preliminary decision as to the width of the margins (the space around the artwork) you would *like* to allow. This is a judgment based primarily on personal taste, the significance of the contents, and the image you want the work to convey. Do the contents present information, or are the words meant to be of lesser importance

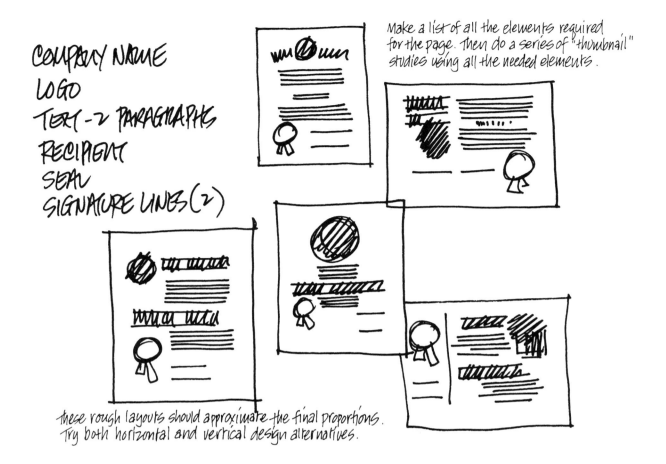

COMPANY NAME
LOGO
TEXT - 2 PARAGRAPHS
RECIPIENT
SEAL
SIGNATURE LINES (2)

Make a list of all the elements required for the page. Then do a series of "thumbnail" studies using all the needed elements.

These rough layouts should approximate the final proportions. Try both horizontal and vertical design alternatives.

than their appearance? Is the page meant to suggest elegance, grandeur, dignity, or serenity, or is it simply communication of the most direct kind, such as a six-course menu? Margins, surprisingly, exert considerable and immediate influence on the page. Border space can be thought of as a visual enclosure, functioning in the same manner as a mat for a watercolor. It defines what a viewer should see and focuses attention on that area only.

Large margins convey elegance, but artwork appears to "float" or "drift" when margins are too wide. Extremely narrow borders, on the other hand, tend to "strangle" art and create internal tension and stress. A general determination of border space, sketched in the earliest roughs, will also serve to direct your attention to that critical space in which the bulk of the work will be rendered.

Another consideration is the relationship between the top, bottom, and side margins. There are basically three options. The first, and least desirable, are margins of equal size all around. The second alternative is to have sides that are equal and the top and bottom margins equal to each other but wider than the sides. Finally, the most popular solution is to have the sides and top equal in width but the bottom edge wider. There is a subtlety involved in both the second and third options, which is determining just how *much* wider a border need be. My suggestion would be

to use a dimension that makes an appreciable, visible difference. If the top and side margins are two inches, for example, try a bottom margin of three inches—anything less would probably have little impact.

Justification. The margin is most often a rectangular border that surrounds a body of type. However, it is only rectangular if the copy, text material, or illustrations have that shape. Lines of text combined with headings, lead-ins, and illustrations can produce a layout configuration other than the perfect geometric form. In typography, the shape and alignment of lines of text is called "justification." The term is applied to both the left- and right-hand borders, and there are a variety of ways in which the shape of these borders is described. They include "flush left and right," which is evenly aligned on both sides or "justified." "Flush left and ragged right" describes even left and jagged right. "Ragged left and flush right," "centered," and "asymmetrical" are other possibilities. As far as the calligrapher is concerned, the first two layouts are the most comfortable for reading purposes, and the second arrangement is easiest to construct. The remaining three can be quite esthetically pleasing, but they are uneasy for the eye and much more difficult to design.

Margins

Margins are excessively large. Artwork appears to "float."

Margins are too narrow. Artwork feels cramped.

These margins are better proportioned to artwork.

These margins are the same width on all four sides.

Top and bottom borders are the same but wider than the sides.

Three sides are identical but the bottom edge is wider.

Text lines are "flush", left and right.

Lines are "flush" left, but "ragged" right.

Type lines are set to form a distinctive shape.

These lines of type are set "ragged" left and "flush" right.

This is an "asymmetrical" arrangement of type lines.

THE ASSIGNMENT

It is not unusual for a client to present material to the calligrapher in crude form. I have been given lines written with a pencil borrowed from a waiter on a luncheon napkin. (I admit neither the client nor I had the foresight to bring along more serviceable materials and tools.) The more acceptable form, of course, would have been a clearly typed page.

Before the final typed copy is given to the scribe, it is helpful if the following basic considerations have been determined:

1. The text material, along with other copy, has been proofed for accuracy of names, dates, places, spelling, grammar, and punctuation.

2. The sequence of information has been agreed on.

3. The focus has been established.

4. Accord has been reached on size, color, material, deadline date, and price.

If the forementioned are discussed there is a good chance of preventing misunderstandings later that could result in innumerable problems. There need not actually be a signed contract. A follow-up letter to your client restating all items that were discussed is fairly standard business procedure. In many cases, the client will give the calligrapher total responsibility for everything other than the deadline and the price!

 to: Client's name

 from: Calligrapher's name

 subject: Art assignment

Pursuant to our conversation of (date), I would like to confirm the details of the project as discussed.

 1. Description of the required art and what will be
 turned over to the client.

 2. Deadline date.

 3. Fee for services rendered.

If these facts meet with your approval, please sign the enclosed duplicate and return it to me.

Thank you.

 Sincerely

Refinements can be added to a basic agreement of this type as the situation demands.

COPYFITTING

If the copy to be lettered has been written out by hand, it would be to the artist's advantage to type it for maximum clarity and, in the process, begin the layout procedure by trying to establish and organize the sequence of lines. It is best to set the margins, say for 60 characters per line, and type each line as close as possible to that width, within about three characters. Type double space for easier readability. After the page has been typed, proofread it again. (It would be disastrous if a mistake was made in typing and subsequently repeated when lettered!) At this point the alignment of the typed page will probably be flush left and ragged right.

The process we will use to convert the typewritten material to handlettering is similar to what is called "copyfitting" in typography. For calligraphy, however, we do not use an identical procedure since we do not work with the mechanical exactness needed for print-

ing. The human hand cannot produce letterforms and spacing of identical size over and over again. The first step in this procedure calls for properly identifying the typewriter used. Pica type has 10 characters or units to the inch; elite is a shade smaller, with 12 characters or units to the inch. Once the typewriter size has been determined, we can calculate the total number of units for the manuscript. If you have typed it yourself, you will have set the margins beforehand and thus know there are so many units per line—let's say 60. The total units would then simply be 60 units per line times the number of lines. If the client presented you with typed manuscript, on the other hand, you must proceed differently. First look at the ragged edge of your typed manuscript and select a line that is average in length, one that is neither exceedingly long nor short. By measuring this line with a ruler, the number of characters or units—which includes letters, punctua-

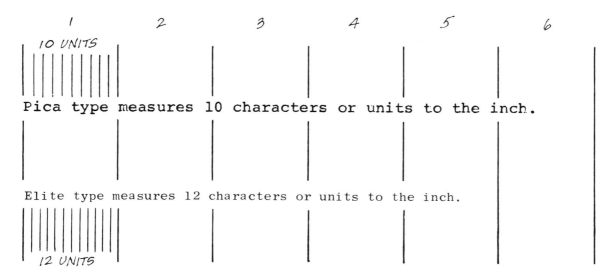

The process of copyfitting is considerably simplified by first identifying the typewriter used and then measuring a line. The number of units in that typewritten line will be determined by its length times the quantity of characters per inch.

tion, and spaces—can be quickly established. If this representative line is five and one-half inches long, and a pica typewriter was used with 10 units to the inch, then there are 55 units in that line. Using this rough count, we can get some idea of the total number of units in the manuscript by multiplying the 55 units by the number of lines. This abbreviated description does not provide a precise count, since we have not accounted for the number of units that exceed or fall short of the average length we selected. Nonetheless, it will be close enough for your needs and will provide sufficient information to proceed with confidence.

Character counting permits you some insight into how much lettering can be put in a given width, and how closely you can come to "squaring" the copy to a border, flush left *and* right.

Once the typewriter size has been determined, we can calculate the total number of units for the manuscript. If you have typed it yourself, you will have set the margins beforehand and thus know there are so many units per line--let's say 60. The total units would then be simply 60 units per line times the number of lines. If the client presented you with a typed manuscript, on the other hand, you must proceed differently. First look at the ragged edge of your typed manuscript and select a line that is neither exceedingly long nor short. By measuring this line with a ruler, the number of characters or units-- which includes letters, punctuation, and spaces--can be quickly established. If this representative line is five and one-half inches long, and a pica typewriter was used with ten units to the inch, then there are 55 units in that line.

A more accurate character count is achieved if the excess units to the right of the vertical line used to indicate average line length are used to fill in the spaces that fall short of that line. Overflow units are then added to the last line.

The next step is to convert this knowledge into handlettering. Knowing how many characters and spaces there are in a typewritten line and page does not, as yet, give you any idea of the area required when these units are converted to handlettering. Suppose the total unit count was 55 units per line multiplied by 15 typewritten lines (plus 10 units), or 835 units in all. First letter a line by hand to the width prescribed in the layout. Let's say that dimension is 10 inches (25.4 cm), and Italic script 3/16 of an inch high (4.8 mm) has been selected, then the line must be precisely written in that hand at that height. This line should be lettered to the full 10 inches, even if a word is split at the end. It should also be written and spaced as carefully as if it were part of the finished piece. In other words, the line should represent, in both letterform and space, all the lines that will subsequently be written. (In typography, the number of letters in a particular typeface and size needed to fill a fixed length is more easily determined because the forms are more exact.) Now count all the units in the line, counting two spaces between sentences if this should occur. Let's say there are now 63 units. Divide the total, 835, by 63, which gives us 13 lines plus 16 units left over. Thus, a little over 13 handlettered lines are needed to complete the manuscript. Also, by using this yardstick figure—63 units per line—you can confidently anticipate the appearance of an awkward word or sentence break by counting off against the typed copy and therefore adjust letter and word spacing accordingly.

which includes letters, punctuation, and spaces--can be

quickly established. If this representative line is five

which includes letters, punctuation, and spaces- can be quickly

10"

By first lettering a prototype line in the selected hand and to the dimensions required in the finished art, the calligrapher can establish, with reasonable accuracy, the number of handlettered characters required for a given space equating to a typewritten line.

other hand, you must proceed differently. First look

at the ragged edge of your typed manuscript and select

other hand, you must proceed differently. First look at the ragg

Using our handlettered line as a guide containing 63 units, we can anticipate, to some degree, where difficult breaks might fall. The above illustration shows that 63 units in this sample typewritten line would break the word "ragged."

Once the typewriter size has been determined, we can calculate

the total number of units for the manuscript. If you have type

d it yourself, you will have set the margins beforehand and thu

s know there are so many units per line--let's say 60. The tot

al units would then be simply 60 units per line times the numbe

r of lines. If the client presented you with a typed manuscrip

t, on the other hand, you must proceed differently. First look

at the ragged edge of your typed manuscript and select a line t

hat is neither exceedingly long nor short. By measuring this l

ine with a ruler, the number of characters or units--which incl

udes letters, punctuation, and spaces--can be quickly establish

ed. If this representative line is five and one-half inches lo

ng, and a pica typewriter was used with ten units to the inch,

then there are 55 units in that line.

To better anticipate word breaks, the text material can be retyped evenly to 63 units per line. This would clearly show, as in the above example, that a word is frequently split by only one letter and can be easily squeezed into a line if anticipated.

Once the typewriter size has been determined, we can calculate||
the total number of units for the manuscript. If you have type
d it yourself, you will have set the margins beforehand and thu
s

Once the typewriter size has been determined, we can calculate the total number of units for the manuscript. If you have typed it yourself, you will have set the margins beforehand and thus

The retyped text shows us that the first line should be expanded to fill one space. The second line needs tightening to absorb the "d" with the extra "s" eventually taking over the "d" space.

ILLUSTRATIVE MATERIAL

Artwork in addition to handlettering is occasionally called for, and its impact on the total page should be considered as part of the layout process.

While illustrative material can take many forms, the first evaluation the artist must make is to establish its importance relative to the entire page. If the art is of major significance and the calligraphy will be constructed around it, the client will probably employ an illustrator and simply provide you with a layout that includes space for the rendering. In that case, two specialists— you and the illustrator—will share in the resolution of the final piece. If, however, the required pictorial work is within your capabilities, then you must determine its importance and treat the layout accordingly.

DUPLICATION

Illustration, supplementing or working hand in hand with calligraphy, can be of many levels of complexity. At times art may involve no more than the precise duplication of a logo, seal, crest, or coat of arms. This is not creatively taxing,

but it does require technical competence to copy a form to its exact proportions, color, and content.

First determine if you are capable of rendering an exact duplicate of this symbol, particularly if it is very complicated. You will probably have to use mechanical drawing tools to re-create the form and colors to ornament it. It is also very possible that built-up lettering may be required, often based on a contemporary type style rather than a historical alphabet. If the assignment is not within your capabilities it would be better to consult with your client and perhaps bring in a professional illustrator. I also suggest you establish the layout and do your portion of the work before giving the piece to the artist. This, in effect, places the pressure of not making a mistake on a piece of original art on the illustrator rather than on you.

A client will frequently give you a sample of his logo, which provides all the necessary graphic information but is too small to trace and transfer to your layout. A photostat service (see Chapter 8, *Production Methods*) can help you "scale up" the logo to the precise size

Duplication

Original art.

After the original art has been photostatically enlarged to the desired size, an accurate tracing of the image is made.

The tracing is turned over and all the linework is covered with a coating of graphite. A soft, grade "B" pencil can be used for this purpose.

Finally, the tracing is returned to its proper side, positioned into place, and redrawn, using a harder, lead pencil. This will transfer the image, which will probably require some sharpening up before painting.

(Logo design by Karl Prinz of Germany for the Droste and Sohn Company.)

required. Then make a tissue tracing from the photostat and place it in position temporarily and check for size again. If it is accurate, then apply a light coating of graphite with the side of an HB pencil to the back of the tissue, stick it in place on what will be your finished piece with drafting tape, and re-outline the design to transfer the image. Remove the tissue, but do not throw it away. It can be used again and will save steps in the event of a mistake. The transferred design will now look a little fuzzy and uneven. Use a sharp HB pencil to redraw the image precisely. Now, with a dry-cleaning pad (see page 45) rub lightly over the entire design to remove the blurriness but still leave a sufficiently clear, clean image to render. Brush away the residue carefully, making sure all extraneous material is removed from the paper surface.

One final thought before painting the design: if you feel this portion of the assignment is more difficult than the handlettering, do the easy part first. It is only realistic thinking to be conscious of the possibility of making a mistake. If it becomes necessary to redo a page, then it is certainly less agonizing if it is the easier portion of the project that needs to be redone.

MECHANICAL TOOLS
How a design is copied is mainly determined by its complexity. Even the simplest of forms can be enhanced, however, by excellent technique and crisp precision; mechanical drawing instruments can provide this. I find that a ruling pen combined with a French curve and a small, plastic triangle are most helpful (see Chapter 2). The ruling pen is made of two stainless-steel flanges with an opening in between that is controlled in size by a set screw. Paint or ink is placed in this opening, and the

screw is adjusted to make the opening larger or smaller depending on the width of line desired. The pen is then used to outline that portion of the design to be filled in. This outlining process defines a painted area cleanly. Use a small pointed sable brush to fill in the area with the same color used for outlining. Generally speaking, I prefer using Pelikan designers colors, which come in jars, for projects of this type. Also, as a matter of practice, I try not to combine paints with inks in any one design. If black is required I will use paint rather than ink to maintain consistent color character on the page.

INTEGRATING THE ART
The most direct way to combine an illustration with lettering is to enclose the artwork in a geometric shape. A rectangle, circle, or oval is easier to work with than a freer, less defined

Geometrically enclosed artwork is more easily integrated into a layout.

form. Geometrics are more static forms, however, and influence the overall character of the composition by suggesting geometric layouts that use blocks or columns of lettering. Outlines and enclosures should be made with the ruling pen or ruling compass combined with the plastic triangle and French curve. Draw the border lightly and accurately in pencil first. If the border has any thickness—more than 1/16 of an inch (1.6 mm)—then draw and rule parallel lines and fill them in with brush and ink or paint. Smaller widths can be built up with the pen or compass. Do not try to set your instrument to draw a full-width line in one stroke. Until you are totally familiar with the ruling pen

and compass, it is far more advisable to draw several thin lines to build up to the desired width than risk the possibility of blobbing because of heavier ink or paint flow.

The width of outline enclosure should be determined by the contained artwork. It is an esthetic determination and is similar to selecting a frame for a painting. Some work requires ornate mouldings, while other pieces need only thin, delicate stripping. Whatever the case, understand that a border should not call attention to itself. Its sole function is to define and contain the artwork and allow the eye to focus before concentrating on the calligraphy.

Free, uncontained illustrations per-

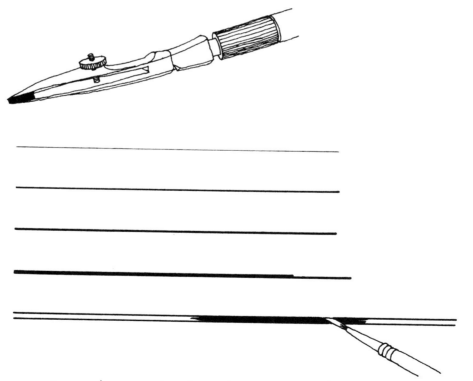

A ruling pen can be used to draw border enclosures of varying thicknesses. A border that is about 1/16 of an inch can be built up with two overlapping ruling pen lines. Wider borders should be outlined first and then filled in with a brush.

mit layout flexibility, but also make visual balance difficult. Free-form layouts used well can be more dynamic and less formal, and allow you to be more inventive. Occasionally adding a small, decorative element, selectively placed, will balance and offset the weight of artwork in an asymmetrical composition. I have, at times, been able to successfully integrate a hairline rule of metallic gold both horizontally and vertically in a page. (Pelikan also provides jars of metallic colors that are quite rich in appearance and can be watered down for ruling pen use.) While it is not good design practice to add decorative elements at the last minute, hairlines are delicately unobtrusive and can be a nice finishing touch.

EMPHASIS AND "COLOR"

There is, of course, a great deal of pleasure when you have successfully completed a project that began with disparate parts and is now assembled into a visually pleasing whole. The juggling act is over.

After the warm glow of accomplishment dissipates, the learning process begins again. Place the finished piece out of sight, protectively stored for a day or more if deadline considerations permit, until that time when your cool, objective eye can review the work again. Lean the work against a bare wall (no patterned wallpapers, please!) or on an easel backed by a plain color (cream or light gray matboard) so the eye is not distracted by surrounding colors of ob-

Uncontained art can frequently lead to more flexibility and innovation in layout design.

jects. Squint your eyes, deliberately blurring your vision, and consider the *mass* of material you have drawn and painted. Do not try to read the words or evaluate the illustration. Instead, try to see all the forms as a compact unit that occupies a space bordered by a band of white. Is this mass too large? Is its "color"—the black, white, gray *value* properties—too dark or too light? Is the portion that includes the illustration too heavy or weighted to one side?

Now focus on the components. Are the painted areas too intense, too bright, or distracting? Is the heading too large and overly important, the interlinear spaces too wide? These and other questions can only be answered after the assignment has been completed and candidly assessed. An honest evaluation of one's own work not only sharpens your design sensibilities, but is of vast benefit when developing and executing future commissions.

Evaluate the "color" of a finished piece by squinting to blur your vision. Read the mass areas in terms of their value — the degree of lightness or darkness in a given area.

Check to see if these value areas are balanced through the layout. Consider the weight of the handlettering against the other forms.

AN ATTITUDE ON READABILITY

The experienced calligrapher is occasionally the unwitting victim of his own talent and expertise. As technique develops and design attitudes mature, each calligrapher naturally wishes to infuse his or her work with greater personal expression to create a more individual statement. Artists and craftsmen have no doubt always fought this internal conflict between what they create for others and what they do for their own pleasure at their own discretion. Stated another way, there is nearly always a small tug of war between commercial ventures controlled by a client and the professional gratification of the calligrapher's own efforts. The most pleasing resolution of this conflict is that happy situation when the artist is paid for work done with complete freedom and solely by his own standards.

Perhaps the first quality the experienced calligrapher sacrifices to personal expression is readability. There is a built-in hazard in technical facility—this ability to create handsome forms with ease. Understandably, for any artist there is joy in being "on top of his game," master of his instruments. With this achievement, however, comes the responsibility of his discipline. The moment the scribe commits himself to a client, this responsibility must be acknowledged and carried through until the assignment is complete. It is not that creative instincts need be confined to function commercially. It is, instead, the gathering of esthetic energies in response to an artistic challenge.

If an example is needed to illustrate the hazards of the indulgent use of talent, look at the rise and eventual downfall of the Copperplate hand. This hand deteriorated when the scribe began to compete with the engraver and attempted to draw the finer hairline, the more ornate flourish, and the more lush

Readability, in this Copperplate example, has been sacrificed for decorativeness and technical facility. Pen skill is very evident but the impact of the word has been lost.

swell—to the eventual detriment of clarity of form and readability. By contrast, consider oriental calligraphy, which functions as both communication and "fine art." At a certain level it becomes Art yet still communicates to a larger audience. The symbols are beautiful, the stroke components spoken of in terms of their "strength," "ex-

uberance," or "delicacy," but the words themselves can be, and frequently are, poetry.

My "message," therefore, is that the happiest combination of calligraphic efforts results from a disciplined desire to communicate in forms that are beautiful, personal, and readable.

My brush calligraphy is readable but quite impersonal. (The two symbols mean "fearless.")

A master calligrapher would translate the forms into Art, but nonetheless, readable.

The Use of Color

ADDING COLOR to a page, either as part of an illustration or in the lettering itself, introduces a new dimension that affects all of the elements on that page and requires—if proper balance is to be achieved—temperate use and disciplined design.

Historically, color in calligraphy probably peaked in the beautifully illuminated manuscripts of the Middle Ages. In many ways they established a format for the use of color in ceremonial documents that is still very much in use today. The medieval scribe understood that color draws attention to itself, that its abuse would only serve to diminish the overall image. For that reason, color was frequently reserved for the specialists: the illuminators and rubricators. The rubricator derived his name from the Latin word, *rubrica*, meaning red earth or red ochre coloring. His function was to use red paint or ink to decorate portions of a manuscript ranging from marginal notes to enlarged initials in opening sentences. *Rubric* also means a section heading and old manuscripts of the Gothic period show entire prefaces, prologues, and notations other than the text written in red. Eventually, and perhaps inevitably, the rubricator broadened his palette to include other colors, but the traditional definition restricts him to red. In any event, the use of this color served as an effective bridge between the black text lettering and the richly colored effects of the illuminator.

It is natural to assume illumination meant the laying of gold leaf on medieval manuscripts to brighten and decorate the page. This is true, of course, but the illuminator was also an illustrator, designer, and colorist, who used reds, greens, blues, and blacks with expertise. To illuminate, therefore, in its broad definition, means to lighten or bring to

life the image of a manuscript page.

Our problem today—if indeed it is a problem—is the wealth of inks and paints available to choose from. Today color is made in a full spectrum, for the most part reasonably well manufactured, and comes in powders, pans and cakes, paste, and liquids. Quality and price vary, but even the finest colors are not beyond the reach of the calligrapher. This enormous selection of colors can create a tempting situation for the calligrapher. Having too much color can be a problem equal to not having enough, and the use of more color can never save a piece that is badly lettered to begin with. When used properly, color augments, emphasizes, and decorates, but never rescues.

TYPES OF COLOR

There are at first glance an enormous variety of colors from which a calligrapher can choose. Visits to your art-supply store show oil colors, acrylics, and watercolors, with subcategories called tempera, showcard, casein, gouache, and designers colors. Along with these items, we have colored inks, concentrated dyes, fluorescent colors, and metallic paints. To further add to the confusion, these colors come in a variety of forms. There are tubes, jars, bottles, cakes, and even powders if you want to mix your own. (I have not included colors available in felt markers, having already discussed them in Chapter 2 as inappropriate for finished art.) Looks are deceiving, however, and making the proper choice can be considerably simplified.

The first step in choosing the most suitable type of color is to determine your needs. Generally speaking, I feel a paint or ink that can be used in both your pen and brush is best. This factor, among others, eliminates both oils and acrylics. Oils dry slowly and are thinned with turpentine, a solution incompatible with paper surfaces. Acrylics, on the other hand, dry too quickly for pen use and even with the addition of a retarder are difficult to manipulate. Although water soluble, plastic paints do not perform well in a pen. It is true, of course, that neither oils nor acrylic paints were designed for calligraphy. The field, then, becomes considerably pared down to two groups: inks and watercolors.

INKS

Colored inks are well suited for both pen and brush. The colors are brilliant and require no mixing. They are extremely fluid and transparent (we will discuss this quality in greater depth later) and much of their color intensity comes from this characteristic. However, Ralph Mayer, in *The Artist's Handbook of Materials and Techniques*, notes that colored inks "are carefully formulated to meet every requirement except that of permanence of color." He goes on to add that they "can never be relied upon for other than temporary results, and should not be used for permanent artistic work." The question of permanence is subjective and for many artists, color stability (fade resistance) is measured against the span of their own lifetimes. However you regard the issue of permanence, it is important to buy only quality materials. The Higgins, Pelikan, and Winsor & Newton companies produce a fine line of colored inks. The first two product lines have rubber stoppers in their caps for easy, neat pen filling. All can be purchased as individual bottles or in sets. Finally, remember that inks are made

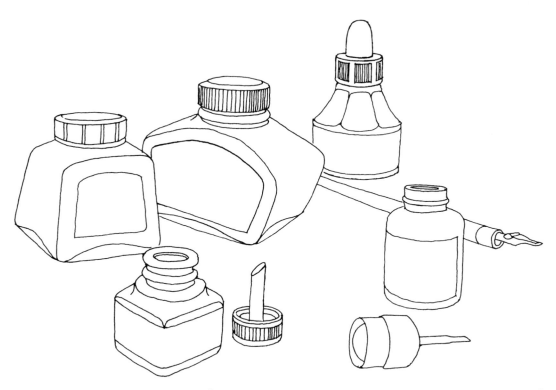

Colored inks are available in a variety of bottles. Some are equipped with rubber stoppers in their caps for easier and neater pen filling. Others have droppers or require pen dipping.

primarily for line work, either by brush, ruling pen, or calligraphic pen. They are not meant for illustrative material requiring large color areas. It is hard to blend these transparent colors into a flat even coat, and they tend to react like watercolor washes in that overlapping strokes can result in streaks of different value. Their thinness causes running and pens, therefore, should not be filled as full as with heavier waterproof black inks. It is always good practice to make a few experimental strokes on scrap paper first to get a pen started and also to assess the heaviness of the ink flow. A colored ink stroke should never pool or "bulge."

WATERCOLORS

Watercolor, by traditional definition, is a paint diluted with water to a thin transparency. In technique, watery solutions of color, called washes, are painted on paper in a series of overlapping glazes that sink *into* the body of the paper. The term watercolor is also used to broadly include *opaque* colors, a property in some pigments characterized by their ability to sit *on* and fully coat the paper surface. Listed below are a number of these water-based paints, all of which are calligraphically usable under certain conditions and subject to personal needs and taste.

Transparent watercolors are available in different size tubes, cakes, and pans.

Transparent Watercolor. This is a classic painter's medium and is better suited for brushes than pen as it is usually thinned to a very watery consistency. It is available in tubes, cakes, and replaceable pans. Both Grumbacher and Winsor Newton have prepackaged sets of tubes and cakes, and the tubes can also be purchased separately. Top-quality watercolors are as permanent as any available.

Concentrated Watercolors or Dyes. These colors, sometimes called dyes because of their high intensity, come in small bottles with eye-dropper dispensers built into the caps. They are definitely not permanent. Only a few drops of these concentrates are needed in sev-eral brushfuls of water to form a color mixture. Water is added only to lower the color brilliance and not to further liquify the colors. They can, in effect, be used directly from the bottle, but are of such intensity that they create visual conflicts in a written page. Colors can be mixed, or a complete set of 36 half-ounce (15 ml) bottles can be purchased in the Dr. Martin's line of products. The Luma brand also offers a set of 16 bottles in a one-ounce (30 ml) size or individual bottles. Use these colors as you would colored inks. They flow with the same degree of "looseness." Fill the pen reservoir with a brush rather than the dropper, which might contain some residue of the concentrated solution.

Concentrated watercolors come in bottles with rubber dispensers built into their caps.
Poster colors are bottled in various sizes or sets, and casein colors are available in tubes.

Tempera, Showcard, or Poster Color. It is unfortunately true that tempera has come to define opaque colors generally. It is also used as an interchangeable name for showcard or poster colors. This is inaccurate, of course, since tempera, as a painting method, preceded oils and the original meaning of the Italian word *tempera* comes from the verb "to temper." Tempering, in this case, meant mixing liquid with pigments for binding and adhesive purposes. Eventually, after oil painting became the most popular form of easel painting, the term tempera was used for emulsion paints (containing an emulsifier). In transparent watercolor, the emulsifier is a solution containing gum arabic. For traditional tempera, an egg yolk serves

the purpose. Given this background, showcard or poster colors (most often seen in elementary classrooms) can be called tempera only in a very broad definition because they are water based and opaque. These paints should not be used for fine calligraphy.

Casein Paints. Casein is manufactured from skim milk and it is the curd, which is combined with pigments, that gives these paints their particular quality. Much as the egg yolk is used in tempera, casein provides the vehicle that binds pigment particles together and gives them adhesion. When these colors dry they are flat in appearance, but they can be given some luster by burnishing with absorbent cotton. These paints have

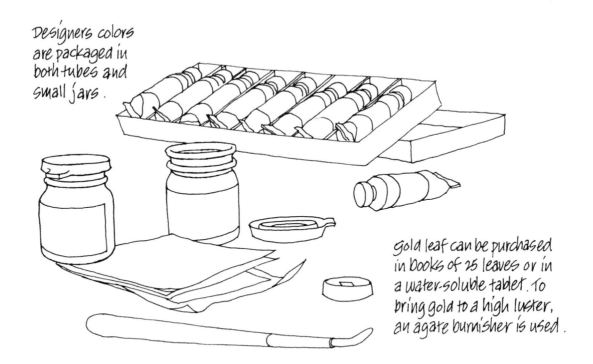

Designers colors are packaged in both tubes and small jars.

gold leaf can be purchased in books of 25 leaves or in a water-soluble tablet. To bring gold to a high luster, an agate burnisher is used.

seemingly fallen out of favor in recent years and have no particular distinction for calligraphic use that could not be better served by another medium.

Fluorescent Watercolors. Available in jars and tubes, these paints can be thinned with water and are probably well suited for certain types of poster work, but they are totally inappropriate for calligraphic use.

Designers Colors and Gouache. These terms are one and the same thing with most paint. Simply stated, they are the opposite of transparent watercolors in

that they are made to fully cover the surface on which they are painted, and their brilliance comes from their ability to reflect light from their own paint surface. Transparent watercolor derives its luminosity from the reflective surface of a pure white paper ground. Designers colors, therefore, are opaque colors and can be thinned with water to a translucent state and still retain vibrancy. They are available in small jars, tubes, and cakes and can be bought in packaged sets or as single units. Grumbacher, Winsor Newton, and Pelikan all have comprehensive, quality lines of these colors, which are as permanent as any available.

a rubricator
added color to
a manuscript page and was
not restricted to the use of
red although his name is
derived from the Latin
word, *rubrica*, meaning red
earth or red ochre coloring.
His function was to both
emphasize portions of the
text and decorate the
page by the discriminate
application of color.

The services of a rubricator were frequently used by medieval scribes to add color to manuscripts. These color accents effected a visual bridge between the richly ornamented illuminated majuscules and the dense black of the handlettered text.

Frederick Wong was born in Buffalo, N.Y. and received his art training at the University of New Mexico where he earned both his BFA and MA degrees. He has been a professional painter, graphic designer, and calligrapher for twenty five years and has taught at Brooklyn Pratt Institute and Hofstra University. His watercolors are carried by private galleries in Katonah, Doylestown, Cincinnati, Dallas, Tulsa, and La Jolla and represented in museum, private and corporate collections. He is the author of "Oriental Watercolor Techniques" published in 1977 by Watson-Guptill, and the forthcoming text "The Complete Calligrapher."

Wong is married and has two children. He maintains both his studio and residence in New York City.

You are cordially invited to attend the Opening of an Exhibition and Sale of Watercolors by Frederick Wong, a member of The American Watercolor Society, Sunday, December 9th, 3 to 7 p.m., at The Ultimate Lotus, 59 East 56th Street, New York City, N.Y.

A calligraphic birthday question addressed to a young lady who is growing at an alarming rate!

A three-color invitation designed to be folded in half. Chancery cursive was used throughout for a richer look

130

celebrate the Year of the Monkey, 4678, at the eighth annual
Chinese New Year Dinner
a benefit sponsored by: Chinatown Planning Council
Saturday, February 16, 1980
Silver Palace Restaurant, 52 Bowery, New York City, 7 pm
$35 per person, $350 per table
for more information & reservations: Attention: Ms S Leung
212/431-7800,7801 Chinatown Planning Council, 13 Elizabeth Street,
New York City, 10013

Flyer / poster / mailer

The Year of the Monkey 4678

Commemorative booklet

A three-piece, 2-color project for Chinatown Planning Council, 1980, using the chinese calligraphic symbol for "monkey" as the unifying design element.

name : _____
address _____

phone : _____
company : _____
sold by : _____
paid to : _____
table no. _____

Chinatown Planning Council's
8th Annual
Chinese
New Year Benefit
Banquet Dinner
Silver Palace Restaurant
52 Bowery New York City
seven o'clock pm
contribution $35.
admit one
Saturday, February 16, 1980

Ticket

THE ULTIMATE LOTUS
"Haute Szechuan & Vegetarian Cuisine"
59 EAST 56TH STREET

212/421-5580 New York City, N.Y. 10022

This is the simplest and most economical way to produce artwork mechanically — a straight-forward black on plain white stock.

THE ULTIMATE LOTUS
"Haute Szechuan & Vegetarian Cuisine"
59 EAST 56TH STREET

212/421-5580 New York City, N.Y. 10022

Reversing the image so that the white lettering is the unprinted part of the paper is also reasonable in price but requires a "bleeding" of all four sides and then trimming to size for a clean black edge all around.

THE ULTIMATE LOTUS
"Haute Szechuan & Vegetarian Cuisine"
59 EAST 56TH STREET

212/421-5580 New York City, N.Y. 10022

Here we have reverse printing, with the lettering again the white of the paper. However, a color other than black has been used and although it is still only one color the printer will charge extra for the labor in cleaning his press of the "usual" black ink.

THE ULTIMATE LOTUS
"Haute Szechuan & Vegetarian Cuisine"
59 EAST 56TH STREET

212/421-5580 New York City, N.Y. 10022

This is still one-color printing.
The black plate is used this time
on a colored stock instead of plain
white.

THE ULTIMATE LOTUS
"Haute Szechuan & Vegetarian Cuisine"
59 EAST 56TH STREET

212/421-5580 New York City, N.Y. 10022

This is a three-color job. The back-
ground color is printed, holding out
the white for the name and address.
The red and black are overprinted.
As a result, the red—but not the black—
loses some of its color intensity.

THE ULTIMATE LOTUS
"Haute Szechuan & Vegetarian Cuisine"
59 EAST 56TH STREET

212/421-5580 New York City, N.Y. 10022

This is another three-color job, but
here all three colors are printed on
a white background, which will
print each color to its fullest intensity.

*from our house
to your house...
Warmest Greetings
in this most joyous
of seasons!*

Copperplate seemed appropriate for both the holiday occasion and in conjunction with the line drawing of the client's house. The black plate is overprinted on top of the red.

COME JOIN US.... FRIDAY, MAY 23RD, 6PM

A HOUSEWARMING!

12765 QUAKER LANE CHAPPAQUA, NEW YORK

Evan, Annette & Jesse Norris

This straight-forward housewarming invitation emphasizes the drawing of the house, with the calligraphy providing the required information in a simple and direct manner. There is only one plate — black — but it is printed onto a colored card stock.

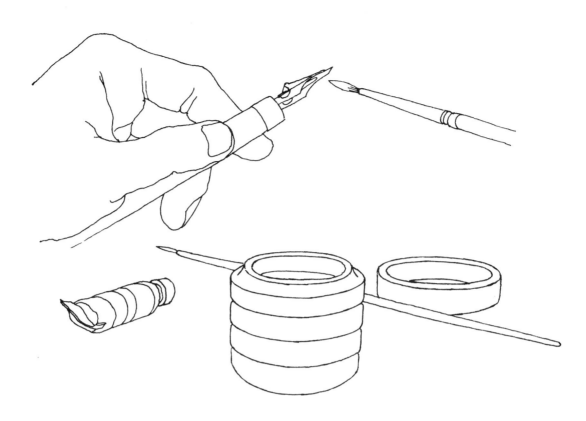

Use a small, pointed sable brush to fill the reservoir of a pen. A stack of porcelain wells is a convenient alternative to the flat palette with recessed wells.

sizes ranging from a 00 to a No. 5 can be used for all the water-soluble mediums. The larger brushes can be used for filling pen reservoirs, a practice I prefer even with the bottled color inks because it is easier to control. I also prefer porcelain palettes over aluminum, which seem to cause paints to pool and puddle. There is also a plastic palette that I have found quite convenient when using designer's colors. It contains six slanted wells for mixing along with six cups with airtight caps for storing colors. Finally, all brushes should be immediately cleaned with warm water and a mild hand soap after use. Pay particular attention to the area where the hairs enter the metal ferrule. If paint is allowed to dry there the hairs will be prevented from reassuming their natural point. To wash out this area, press the brush vertically into a soap solution cupped in the palm of the hand. The hairs will fan out in a circle and the brush can then be rotated around in the soap and rinsed in warm water. Both brushes and pens used with the metallic paints require more frequent cleaning as these paints dry more quickly. It is wise to clean these tools even in the middle of an assignment to avoid the possibility of frayed brush strokes and pen lines.

TRANSPARENCY AND OPACITY

The property of color that initially has the most significance for the calligrapher is that of transparency or opacity. Determining which quality is needed for a particular piece is one of the first decisions the scribe should make. Thereafter, the importance of color lies in how it is used to enhance the page.

The term "transparent," as applied to paints and inks, describes a color's ability to cover the surface on which it is used. It is not "clear" in the sense that a pane of window glass is fully transparent. The meaning here is the density of the solution and the degree to which it covers or reveals what is underneath. It would be more accurate to refer to this quality as "translucency," which is a middle term somewhere between that which is truly clear (as if one wrote with unpigmented water) and total opacity. However, we do use the term transparent to imply a fluid medium that conveys a color and is "loose" enough to be used in our pens. Colored inks, for example, are paint mixtures that have been watered down to the consistency of what is called a "wash" in watercolor, where pigment is deliberately diluted to both reveal and affect the color underneath. A disturbing characteristic of transparent inks and paints is the difficulty of flow control, which affects the scribe's ability to smoothly construct crisp strokes and hairlines. Watery solutions also tend to collect and pool at the bottom of strokes when working on a slanted board and can inadvertently run, leading to smearing. This pooling of color, however, can also be used to advantage if allowed to dry in place. It creates soft shadings of value, the bottom of a wet stroke being darker than the top, and it is particularly effective when used in a large heading to achieve a fresh, contemporary feeling.

"Opacity" is the opposite of transparency, describing a color's ability to fully cover a surface, effectively concealing what is underneath. The term can never be applied to colored inks, since these are, even in their most intense form (directly from the bottle), already transparent. Paints can be thinned to translucency, but nothing can be done to inks to render them opaque without substantially altering their character. Paints are never used directly from the bottle or tube; they require some water in order to increase their fluidity for both pen and brush use. Considerable skill and practice are needed to add just the right amount of water in order for the mixture to flow and yet remain opaque. Remember, no matter how accurately paint has been mixed, it will always dry more quickly than ink so it is advisable to clean the pen and reservoir frequently.

Whether a calligrapher chooses the transparent medium over the opaque is really a matter of personal esthetics. However, there are considerations that can affect your decision. Transparent colors "feel" lightweight compared to opaque colors. Combined with large blocks of black text material or with a dense alphabet such as Blackletter, transparent colors do not seem substantial. Transparent inks are also considered impermanent, and if this is important to you it might be better to switch to transparent watercolors.

The fact that transparency implies a watery solution can also be used to advantage. It is particularly effective in large letters where pools of color are allowed to collect to create deeper values. A second color can also be intro-

transparent
watercolor

Transparent watercolor can be difficult to control and has a tendency to pool at the end of strokes. It will also not conceal guidelines that are drawn too darkly.

opaque
watercolor

Opaque watercolor is used in more dense mixtures and is more controllable. It will cover the paper surface in a uniform coating and is capable of concealing guidelines.

duced into the first using a wet-into-wet technique with the two colors merging in a free and spontaneous manner. Remember that any preliminary pencil sketching should be kept to a minimum and extremely light as these colors will not cover.

Designers gouache is an opaque paint of great flexibility. I prefer it over transparent colors because it can be thinned to a watery translucent state that will permit pen manipulation without losing its color quality. Used more densely with a brush, it combines well with all alphabets. It is good for illustrative work and is not totally subdued when used with gold leaf or metallic paints.

COLOR FOR THE SINGLE PIECE

The one-of-a-kind commission, the original piece not designed for quantity reproduction, offers the scribe considerable flexibility in layout, lettering style, and color. Generally the scribe has, in this case, the freedom to exercise all aspects of his creativity.

One of the options, or responsibilities, is selecting the color or colors to be used, where they will be placed, and in what values and intensities. The most direct approach, and certainly the safest, is to first choose the color for the text, which immediately defines the largest area. The most frequently used color for text material is black, understandably, since it is the most readable of colors, particularly against the lighter value of the paper background. It is unusual for the paper to be other than white, ivory, beige, or tan and, as a result, black will always stand out in high contrast. Having chosen the base color that covers the largest portion of the page, the artist can then focus on the balanced distribution of other colors.

Traditionally, along with black, the most favored colors were red, blue, and green. When combined with the illuminator's judicious use of gold leaf, these colors produced a surprisingly rich palette. By varying color intensities and values, even greater subtleties were achieved. Other colors, such as yellows and browns, were also used, but not with the frequency of the forementioned.

The contemporary calligrapher has all these colors and more from which to choose and so would be well advised to minimize the number of them used in any one piece. Begin with one color, perhaps vermillion, in addition to black. Historically, the use of vermillion dates back to earliest Egyptian times. Its popularity may well be traced to its ability to establish emphasis with subtlety and grandeur, but without resorting to a visual "punch in the nose." Vermillion is made from mercuric sulfide and falls into the red-orange range of colors; it is interchangeable with cadmium red light.

Limiting yourself to one additional color will make it easier to contend with the complicated balancing act you must perform when a variety of colors is played not only against one another, but with the black as well. As confidence grows with practice, slowly add other colors, always keeping in mind that moderation and restraint should be exercised. An explosion of colors can only distract attention from the focus of the work and ultimately diminish its readability.

COLOR FOR QUANTITY ORIGINALS

Color for quantities of the same item that are all original works (and not mechanically reproduced) is a relatively

simple process. The only built-in hazard is one of error through boredom.

The first and most obvious consideration in doing many identical pieces is that the scribe must have confidence in the model manuscript from which all the others are duplicated. Few things are more depressing than seeing a quantity of work that is less than successful to begin with. Assuming all professional standards are upheld, however, then quantity production is no more than a matter of maintaining color fidelity from piece to piece.

Let me add here that quantity orders of original work, particularly major works, are rare. A client does not normally require a dozen identical certificates, each individually handlettered. More likely the scribe would be filling in the names on printed certificates, or lettering a quantity of small items having very little copy, such as formal dinner invitations or individual menus. In any event, the calligrapher must determine how much of any color is needed to cover the quantities required. If a particular color has been mixed by combining two or more colors, it is wise to make more than enough for the job in the event the work carries into the next day. This will preclude the possibility of running out of a unique color and losing much time trying to duplicate its exact shade. When a color must be saved, keep it in a capped container or covered tightly with plastic wrap in a ceramic or aluminum palette. A certain amount of drying will take place anyway, even overnight, and it will probably be necessary to add water the next time the paint is used. Take care not to thin the mixture too much; once an opaque paint has been thinned to the point of translucency, it is virtually impossible to regain opacity. Adding more color will only alter the original character.

COLOR FOR REPRODUCTION

The most common assignments for the calligrapher utilizing color work in quantity involve the job being printed on a press. Here the calligrapher is only required to handletter the original and select a printer's ink that most nearly approximates this written prototype. To accomplish this with a degree of accuracy, it is advisable to use the Pantone Matching System. This system is based on 10 Pantone colors, and when mixed in varying quantities and combinations produce a total of 500 colors. These colors are all assembled in a single volume called the *Pantone Color Selector*. Each color is numbered and can be torn out in small swatches and placed directly on the mechanical. In addition, each color is printed on both a coated and uncoated white stock to allow a more precise reading of ink intensity. Coated papers give colors a brilliant appearance, but the same colors on an uncoated stock will seem soft and muted. There is also a printer's edition of this color selector, which includes instructions for mixing ink in any selected color. The printer is therefore able to coordinate his efforts with the calligraphic designer's instructions. It is also true, however, that your neighborhood printing shop may not have the necessary supplies to oblige you in this manner and you may well end up working from a variety of limited color-swatch books he keeps on hand.

COLOR BALANCE ON THE PAGE

When a job is completed—be it the single original piece, or the quantity production, entirely handlettered or machine printed—it is time well spent to again evaluate the total impact of the piece, to objectively analyze all the

components as part of the final form.

The very nature of color insists that it be noted. How insistently color proclaims its presence on a manuscript is determined by the scribe's ability to control its use. For the use of color is more an esthetic consideration than a technical one. Color can be made to stand apart from the text, isolated and excessively prominent, or act congenially as an integral part of the whole. In looking at the finished art, color should add richness and focus. It should convey a feeling of balance through rhythmic pacing, yet not occur with such obvious regularity that it becomes boring. Perhaps the final question the calligrapher should ask is, "Has my use of color added a dimension rather than a distraction, enhanced rather than confused, and enriched rather than accentuated the superfluous?"

length then that edge is not true. To correct this, move the triangle slightly to overlap the paper and draw a light pencil line to indicate the more accurate edge. The right-hand side of the paper can be tested in the same manner, and the top can be checked by moving the T square up to that edge.

GUIDELINES
Once the paper is taped, you can begin drawing in the guidelines with the T square. Although harder leads give a finer, lighter line, I favor using a No. 2 or HB pencil. I must be careful, however, to draw as light but visible a line as possible with this softer lead, knowing the cleanup afterward will be easier. The first construction line I draw within the working borders is a light, vertical center line. Although a layout may be asymmetrical, I still like to have a mark indicating this position. As one letters, there is some security in knowing how much space is being used relative to the center of the page. After consulting my preliminary layouts, I begin to place all the necessary construction lines for text and headings.

For a large body of text, I will establish one sequence of lines—the four lines necessary for body height, ascenders, and descenders—by measuring with an architect's rule. I then duplicate these same spaces on the edge of a small file card. This card can be placed along the left-hand vertical border of the text area of the paper and the remaining lines stepped off by moving the card downward with light pencil dots placed at each marking. The horizontal lines are then drawn from these marks using the T square. This card method must be used with care and precision, as inaccuracies can occur if the markings become enlarged in the process and take on a thickness of their own.

LETTERING
After the penciled-in structure is finished and before the writing process begins, I usually make some warm-up strokes on scrap paper, preferably the same kind used for the final piece. This helps give me a feeling for the surface I will be working on. Preliminary exercises of this type also serve to loosen up the hand, test the ink flow of the nib, and establish the feel of the holder. After this, I start the actual lettering, beginning with the heading. The reason for this is simple. If a mistake is to be made, I prefer it happening as soon as possible and in an area that would not require a lot of time redoing. I have also found that my hand, even after some warm-up work, is still quite tense in the beginning of a project; doing small text lettering first usually results in tightly crabbed strokes. Headings, on the other hand, are usually larger forms and although hesitancy or tightness would also immediately show, I much prefer their broader, sweeping movements when starting a project.

Text lettering is always difficult. The sheer volume of lines, or perhaps the listing of many names, can play terrible tricks with the mind, hand, and eyes. The mind and eyes tend to leap ahead of the hand, as they do when reading. The most tiring aspect of calligraphy is the effort required to slow down the natural pace of the mind so it is in accord with your hand movements. The mind also interprets what it reads, which can cause spelling errors. It instinctively does not want to linger over a word once read and interpreted, and this results in a struggle for concentration when that word still needs to be written. To focus

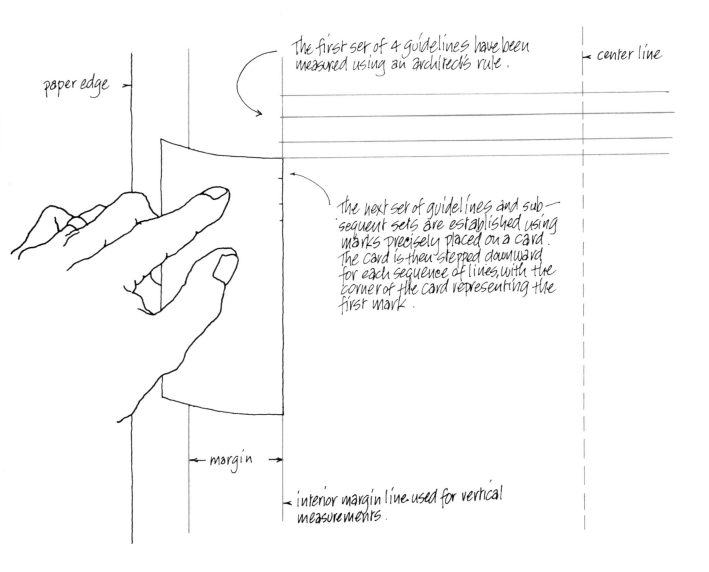

The first set of 4 guidelines have been measured using an architect's rule.

center line

paper edge

the next set of guidelines and sub-sequent sets are established using marks precisely placed on a card. The card is then stepped downward for each sequence of lines, with the corner of the card representing the first mark.

margin

interior margin line used for vertical measurements.

Typed manuscript, double spaced

Small, pencil diagonals mark the pair of guidelines between which the lettering will be done.

A stiff paper template with a cutout opening masks off all but one typed line.

Using a template with a one-line cutout will help to focus the calligrapher's attention.

my eye on the typed copy, I cut a template from a sheet of two-ply Bristol board with an opening just large enough to reveal one line, or one name. The remainder of the copy is therefore masked off. To properly use the template, make sure the copy has been typed with double spacing and in large blocks of text; attempt to break lines in the sequence of the final draft. The template should be lightly taped over the copy, revealing only one line, and gradually shifted to the next line as work progresses.

Another acquired "trick" that helps prevent major errors in lettering lines of text involves making a small pencil notation at the beginning of each pair of guidelines drawn to establish the body height of the text. When lettering text lines on a page literally covered with pencil guidelines, it is very difficult to immediately pick out the beginning of the next "opening" after the previous line has been lettered. In moments of wandering attention, I have inadvertently started a new line of lettering in the space alloted for ascenders! Therefore, it helps to have a visual mark indicating the proper space in which to resume.

After the heading and text have been lettered, it is a good time for evaluation. This is probably the first time the artist can truly see what the project will look like when completed. No matter how thorough the preliminary studies and

layouts may have been, the most accurate assessment can only be made after a substantial portion of the lettering has been done. The contrast of black ink against white paper, properly positioned, will graphically define any problems that may exist in layout and spacing. You may see that additional design elements need to be used in some areas to better define, balance, or simply to enrich these spaces. Sometimes a single, thin line drawn with a ruling pen in color or gold paint can do the job. If a more complicated addition is needed—such as colorful borders or flourishing a decorated majuscule—it is best to first rough it out on a tissue overlay, in color if necessary, and then place it over the original to see if it "belongs." This is the hazard, of course, of introducing new design elements into a piece that is near completion. There is always the danger that these additions will look like last-minute thoughts or part of a rescue operation.

ERASING

When a piece is finally finished, there is a very natural desire to immediately bring it to its final form by erasing all the guidelines. I suggest you wait—allow the finished art to dry completely (at least a half-hour). Believe me, much anguish can be prevented by exercising precaution at this point. Avoid erasing any more than necessary, and under no circumstances make sweeping strokes with your eraser over inked and painted areas. Pencil markings should be carefully picked out with either a kneaded eraser shaped to a point or with a Faber-Castell Magic-Rub eraser (made of a vinyl compound that can be easily cut to a point or crisp edge). Incidentally, all erasing should be done on a surface away from your drafting board, which

should remain impeccable at all times. Remove all extraneous matter from the artwork using your drafting-table dust brush, not the palm of your hand, which could leave greasy marks on the paper surface.

TRIMMING

The final step is trimming the art to its proper size. Here again it is important to be cautious. I prefer using an Olfa utility knife with a fresh blade and a stainless-steel straightedge for this process. Place the art on a piece of scrap illustration or Upson board—a 1/4-inch-thick (6 mm) paper pulp material frequently used in making mats for watercolors—to allow the knife to cut into a soft backing (cutting into a wood, plastic, or metal undersurface can throw the knife out of line). Check the underside of the steel guide for dirt or grease before placing it on the artwork. (For additional protection, a piece of tracing tissue can be placed between the straightedge and the art.) The reason for positioning the guide in this manner is to make the cut *away* from the art and toward the paper area that will be discarded. There have been times when I have unthinkingly reversed this process and a slight wobble in the blade or a sudden shift in the steel guide caused me to cut into an area that was meant to be saved. The straightedge, in any case, should be clamped to the table at the end nearest you using a spring clamp. A sharp, fresh blade should cut through most papers without requiring much pressure or force. However, if you are using two- or three-ply Bristol board it is better to make two light cuts rather than one heavy stroke. The additional pressure could turn the paper edge under and create a rather unsightly lip.

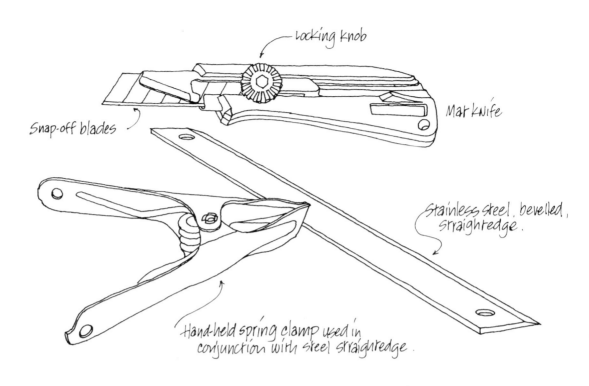

locking knob

Mat knife

Snap-off blades

Stainless steel, bevelled, straightedge.

Hand-held spring clamp used in conjunction with steel straightedge.

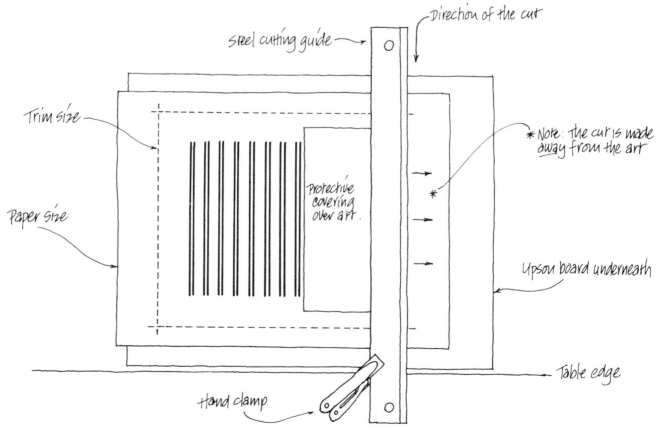

Direction of the cut

steel cutting guide

Trim size

Paper size

Protective covering over art.

*Note: the cut is made away from the art

Upson board underneath

Table edge

Hand clamp

PREPARING FOR QUANTITIES

Preparing the groundwork for a quantity of handlettered pieces is basically the same as for the single item. Differences are caused by repetition, as well as by the particulars of the assignment.

Repetition alone can cause problems, usually as a result of losing your concentration. Quantity assignments frequently call for inscribing names, or names and addresses, in identical formats. Of course this also works to the calligrapher's advantage, since the need for layout is minimal and uncomplicated. A production routine can be set up in which all guidelines on all the units can be drawn first and then the lettering completed without the need to jump back and forth.

Often in quantity work the client supplies the paper stock—envelopes or preprinted certificates, for example—so it is wise to test this paper before you actually begin lettering. Ideally, the client provides a few extra samples for testing and error. If the surface is a little slick or glossy, I scuff the area to be lettered lightly with a draftsman's dry-cleaning pouch (see Chapter 2, *Materials.*) This raises the paper nap slightly, creating a more textural writing ground. Envelopes are frequently of unpredictable quality and when made of a low-grade paper can cause immediate blotting and snagging. If this should prove to be the case, return the envelopes to the client for replacement.

GUIDELINES

The most tedious calligraphic chore is ruling guidelines for a large quantity of pieces. To draw guidelines on 200 en-

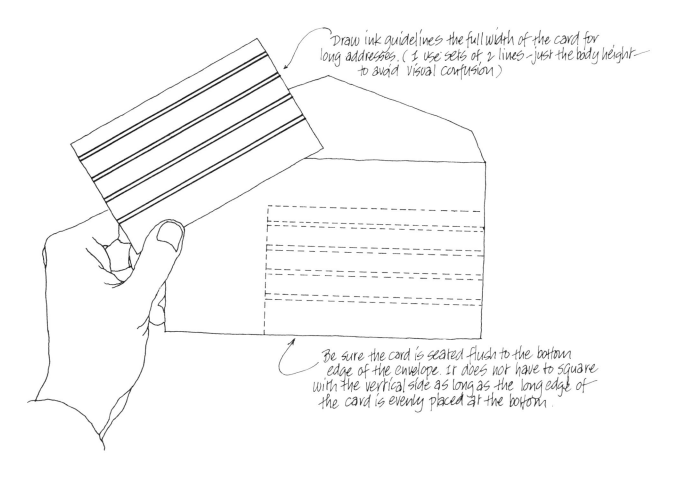

Draw ink guidelines the full width of the card for long addresses. (I use sets of 2 lines - just the body height - to avoid visual confusion)

Be sure the card is seated flush to the bottom edge of the envelope. It does not have to square with the vertical side as long as the long edge of the card is evenly placed at the bottom.

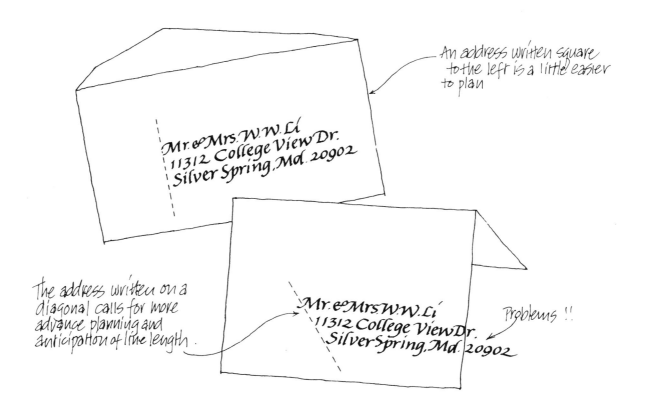

An address written square to the left is a little easier to plan

The address written on a diagonal calls for more advance planning and anticipation of line length.

Mr. & Mrs. W.W. Li
11312 College View Dr.
Silver Spring, Md. 20902

Mr. & Mrs. W.W. Li
11312 College View Dr.
Silver Spring, Md. 20902

Problems!!

velopes is never going to be creatively challenging. Depending on the type of envelope, there is a way to avoid much of this tedium. If it is made of translucent paper, I make a template cut to fit precisely into the corner of the envelope. On this template I draw all lines required for a four-line address (extending the lines across the full width to cover the possibility of long names and addresses). These lines are drawn in very black ink to show through the envelope paper. Spacing and placement of the copy has, of course, already been determined. I favor an address layout that is squared to the left, for both personal and practical reasons. Having all the lines even or "flush" left makes it a little easier to determine line length, while a "centered" or diagonal format requires an accurate anticipation of changing space requirements as each

line is written. There are commercial guides available in some art stores that are designed to ease the construction line process and are meant to be placed on top of the envelope. I have not had occasion to use them and can only speculate on their convenience. It would seem, however, there might be some question as to the possibility of conflict over the esthetics of line spacing relative to lettering size, letterform, and height of ascenders and descenders. If these matters have been anticipated, the guides may be perfectly usable.

For heavy and opaque envelopes and for certificates, where the template cannot be used, I accelerate the preliminary drawing process by making a *U*-shaped guide that has the exact outer dimensions of the piece. Use card or paper stock that is stiff, yet not so thick as to lift your T square off the surface of the

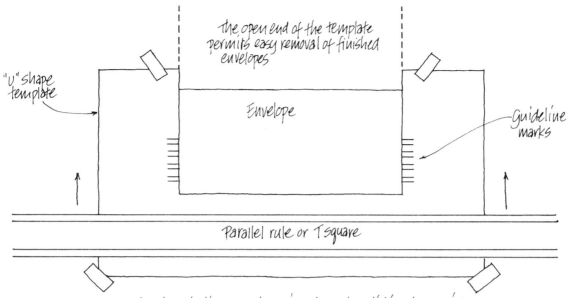

the open end of the template permits easy removal of finished envelopes

"U" shape template

Envelope

Guideline marks

Parallel rule or T square

Pencil guidelines can be easily drawn by sliding the straightedge upwards until it is in alignment with the markings. These guideline marks should be placed on both arms of the template in order for the alignment to be periodically checked.

work material. Next cut a *U*-shaped piece out of this large enough to accommodate the size of the area you will be lettering. This homemade form is then squared to the board and taped down on three sides, leaving an opening at the top. A prototype piece is then inserted into the opening and fitted evenly, particularly at the bottom, with no shifting about that could throw it out of alignment. The guidelines are then drawn across the envelope or certificate, overlapping the edge of the cutout form. These marks on the template will now serve for all the remaining pieces.

THE PRINTING PROCESS

There will probably come a time when the calligrapher will be called on to not only handletter and design a project, but attend to its reproduction as well. Natu-

rally, this requires some familiarity with the printing processes by which art may be reproduced. It is also important to realize that, beyond actually reproducing work, a printer can offer many attendant services: trimming, scoring, folding, collating, gluing, perforating, and sequential numbering.

The printing process is simple in theory, but intricate in practice. For art to be printed, it must first be photographed, the negative used to make a plate, the plate inked, and then used to impress the image on paper. There are basically three methods of printing.

LETTERPRESS

Letterpress is the oldest of the three printing methods and is also known as "relief" printing. Printing an image with a rubber stamp is one example of relief printing. The area that receives

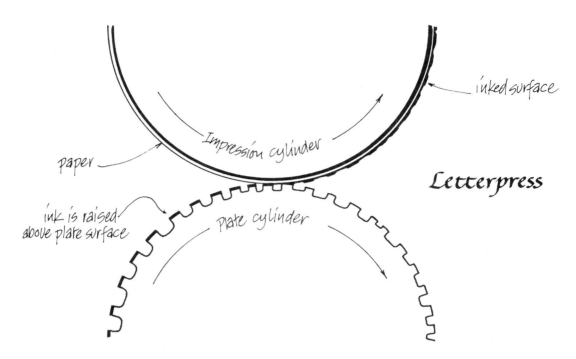

paper

Impression cylinder

inked surface

Letterpress

ink is raised above plate surface

plate cylinder

Letterpress printing creates inked images much as a rubber stamp would, with raised surfaces that are inked and then brought into contact with the paper.

ink and performs the printing sits above the nonprinting portion of the plate. To make a letterpress plate, a process similar to making a photographic print is used. The photographic negative of the original art is placed in contact with a sensitized metal plate and exposed to light. The light, passing through the clear areas of the negative, hardens only those exposed surfaces. The unexposed portions are then eaten away in an acid bath, leaving the image areas sitting slightly above the surface of the plate. This is the part that receives the ink and prints the image. However, before the plate can be sent to the printer, it needs to be "blocked" or mounted on a piece of wood or metal to make it type high: .918 inches (23.3 mm). This ensures all component pieces will, when locked together, make a uniform imprint.

The advantages of the letterpress process are several. It can provide consistent quality, even in short runs. It prints well on papers of any thickness, and permits changes within the elements without requiring an entirely new plate (parts that do not need changing are still usable). It can also furnish on-press die cutting, slotting, perforating, and embossing. Perhaps its two biggest disadvantages are cost and time. Cost is in the middle range relative to gravure and offset printing. The platemaking process in letterpress is lengthy, as is "makeready" time, which is the printer's time involved in compensating for the varying thicknesses of materials used—type, plates, engraving—and getting the press ready to print. This can be a critical factor if you are trying to meet a deadline.

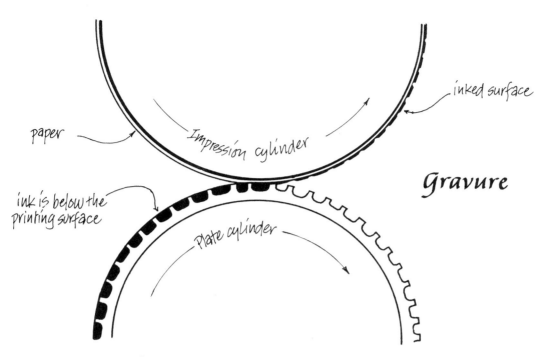

paper

Impression cylinder

inked surface

ink is below the printing surface

Plate cylinder

Gravure

This cross-section illustrates how the ink is actually pulled out of depressions below the surface of the plate in order to create the printed image.

GRAVURE

Gravure is a latter-day form of intaglio printing (etching) that traces its beginnings back to the 15th century. It is the reverse of letterpress in that the image is printed from inked areas etched into and *below* the plate surface. After a gravure plate has been etched, ink is applied to the entire surface. Before it makes contact with the paper, however, a scraper called a "doctor blade" cleanly removes all the ink except that which is held in the recessed areas. Under the pressure of a large cylinder, the ink is then drawn from these wells by the paper, forming the image.

Gravure printing offers one significant advantage over letterpress and offset. It can provide the richest black of the three processes and actually lays down an ink film that is thicker than the other two. There are, of course,

many other characteristics of gravure that would probably be of more interest to the graphic designer than the calligrapher. My experience is that the occasions where I have had to supervise production from beginning to end usually involve relatively short-run jobs. As a result, gravure, which is more economical for high-speed long runs, has rarely been my first choice. Another factor the calligrapher must consider, in addition to cost, is that while gravure printing gives the richest, most dense black, it also requires screening the entire image area, including the type. This is fine for continuous-tone art, but not particularly well suited for lettering with hairlines and delicate serifs. This screening process breaks up the image photographically into a series of dots in order to make a plate. Very small, delicate lettering might suffer as a result.

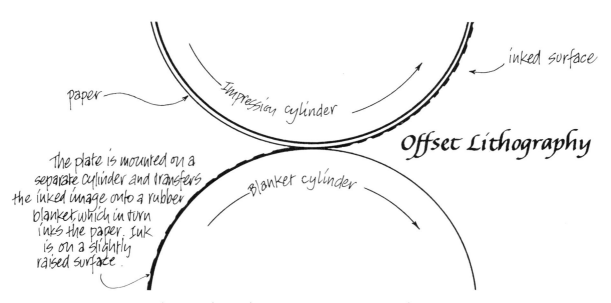

paper

Impression cylinder

inked surface

Offset Lithography

The plate is mounted on a separate cylinder and transfers the inked image onto a rubber blanket, which in turn inks the paper. Ink is on a slightly raised surface.

Blanket cylinder

The process by which the inked image on the metal plate is transferred to a rubber blanket is the reason the commercial method of lithography is called "offset."

OFFSET LITHOGRAPHY

Offset Lithography is the most recent of the three processes and was developed at the end of the last century. It is a more sophisticated version of lithography, where limited editions of artwork were pulled from drawings done with a grease pencil or crayon onto the polished surface of limestone. The principle involves the incompatibility of oil and water. In offset lithography, the image area and the surface plane of the plate are the same; it is the resist process that separates the printing portion from the nonprinting parts of the plate. After the artwork has been photographed, the negatives are then "stripped" into place, as indicated by the mechanical, onto a sheet of heavy paper that has a series of horizontal and vertical lines, similar to graph paper. Holes are cut into this paper, their sizes being determined by the amount of material on each negative. The negatives, in turn, are fixed to the paper with red transpar-

ent tape in alignment with the cut holes. The end result is a page on which all the art and copy material has been masked off except for the parts of the negatives that will produce the images. This is called a "flat," and it is from the flat that the plate is made. Next the flat is placed in contact with a light-sensitized plate of aluminum, stainless steel, or a specially processed paper, and exposed to a high-intensity light. The plate is then additionally treated with chemicals so only the image areas will accept the oily printing inks and the nonimage portions of the plate will reject them. The term "offset" refers to an additional step in which the metal plate transfers its image onto a rubber "blanket" cylinder, which in turn prints the image onto the paper. The reason for this lies in both the fragile quality of the thin aluminum plate and the ability of the rubber blanket to compress under pressure, which allows it to accommodate more textured paper surfaces.

CHOOSING A PRINTING METHOD

Of these three printing methods, offset is the most serviceable for the calligrapher for several reasons. One is availability. Smaller printing companies invariably offer offset service because the process is almost totally controlled "in house," with the possible exception of the camera work. It is well suited for modest runs and the resulting image, in a quality shop, can be excellent. Since plate-making for offset is relatively uncomplicated, printers frequently make their own and this saves time for the customer.

It would seem that offset lithography is the ideal solution for all the calligrapher's printing needs. This, however, does not take into account situations that might better be served by either letterpress or gravure. Long runs requiring consistent quality can be handled more effectively by gravure and be economically competitive with offset, which needs more attention in order to maintain a high image standard. Continuous-tone images are also better handled by gravure. Letterpress is also capable of providing on-press die cutting, a process by which forms can be cut out of the paper as it is also being printed. It can also emboss, a technique in which a design such as a monogram for social or business stationery is raised above the paper surface.

Finally, there is another service that printers will, from time to time, recommend. It is a finishing process that is not relevant to the printing itself and is called thermography. A resinous powder is dusted onto the ink while it is still wet on the paper. The paper is then passed through a heating unit that fuses the powder to the ink, giving it a raised effect. It is meant to give the printed letters the effect of steel-die engraving. I have never found the need to use this process and feel it is not unlike a fake deckle edge made by a machine for paper.

PREPARATION FOR PRINTING

Artwork does not proceed directly from the drawing board to the printer. It must first be prepared for the camera, which then prepares it for the press.

Before any art is taken to the printer, the calligrapher must make several decisions that will have a direct bearing on production methods and, ultimately, the cost. In actual practice, these determinations will have been made much earlier, perhaps when the client first asks the designer-scribe to handle the total production and requires a "ballpark" cost figure. To establish even the roughest of estimates for a client, the artist has to consider several vital elements of his assignment: Does it include color other than black? Is it all "line" art or does it include "halftone" areas? Line material is art that is solid in color, with no value gradations. A halftone or continuous-tone image is art that has value changes, such as a photograph. Since printing can only reproduce solids, in black or colors, intermediate values are photographically "screened." A glass screen on which a grid of fine lines has been ruled is placed between the film and camera lens. The greater the number of grid lines per square inch—they range from 50 to as many as 500—the finer, more detailed the reproduction will be. Other considerations, however, influence the choice of screen. These include the type of paper used, the kind of printing plate, and the quality of the printing press and ink. A newspaper, therefore, will use a coarse 85-line screen because the paper is quite rough, the inks watery, and the presses ill-suited for detailed reproduc-

This "a" is LINE art and shows a uniform value throughout its form.

The gradation of values in this "a" make this HALFTONE art.

a a

This enlarged "a" illustrates the screening process — the breaking up of tones into individual dots — required to reproduce halftone images.

tions. Magazines, on the other hand, use papers that are smoother and will accept finer screens, sometimes as high as 150 lines. Photographing through a screen breaks the image into small dots of varying sizes; when printed, the eye combines these dots into gradations of black to gray to white—thereby creating a full range of tones.

Full-color reproduction of continuous-tone art, such as a painting, also requires screening, but it is a much more complicated process. Color "separations" must be made: a camera process using filters to separate the colors in the artwork into four basic colors: yellow, blue, red, and black. These four separations are in turn rephotographed through a screen to break the image into dots so the plate can be made. These dots must not overlap and must fall into proper relationship to each other, so the screens are each set at a different angle. The end result is an image in full color that is, upon very close inspection, made from a multitude of very small

dots placed side by side in varying patterns. The viewer's eye blends these many solid color dots into the continuous tones that produce the total picture. Understanding whether line or halftone art is required for an assignment helps determine what you have to do to prepare it adequately for the printer, to exercise some control over its final appearance, and to capably make an estimate on cost and production time.

The printer works from a "mechanical," which is a composite of all the pieces—lettering, artwork, rules—in the correct position and ready to be photographed in preparation for plate making. Any changes in layout or artwork after the mechanical has been photographed necessitate reshooting the art, which adds to the cost. Ideally, the mechanical is the exact size as the eventual reproduction, but there are times when it is more feasible for the calligrapher to work larger and allow the camera to reduce the work. This is done by scaling the work up when the lettering

158

Protective cover of Kraft paper

Drafting tape

Crop marks should line up precisely

Bottom plate should be on a stiff board

Occasionally, printers or platemakers will cut holes through the overlays and use just one set of registration marks

Overlays can be tracing tissue or acetate film

Put a color swatch on each plate.

is done in direct proportion to the final printed size desired. Enlarging work in this manner does not mean simply adding an equal dimension to both the width and length. Any change must be proportional since the camera will reduce both dimensions simultaneously.

SCALING

There are two approaches to enlarging or reducing work. The first method requires the use of a T square and triangle. First, a rectangle that is the desired printed size is drawn, with one side of each dimension extending beyond the form itself. A light line is then inscribed from one corner on a diagonal to the op-

posite corner, and carried through to an arbitrary distance. A perpendicular line is raised from the base line at any distance away from the rectangle until it intersects the extended diagonal. At the point of intersection, extend a horizontal line until it meets the side of the first shape. This enlarged form will be exactly in proportion to the smaller version.

A more rapid way to establish proportionate sizes would be to use the proportional scale, a mechanical device comprised of two plastic discs, one larger than the other, attached in the center. The inner disc is marked "original size" while the outer circle is marked "re-

production size." Around the circumference of both circles are numbered measurements. The inner disc is rotated, using one dimension from the original art, until it is aligned with a number on the outer ring that represents the desired enlarged dimension. Once this is accomplished, the second measurement is automatically in alignment. In addition, this scale also gives the percentage of increase or reduction once the measurements have been determined, which is read in a small cutout window on the inner disc.

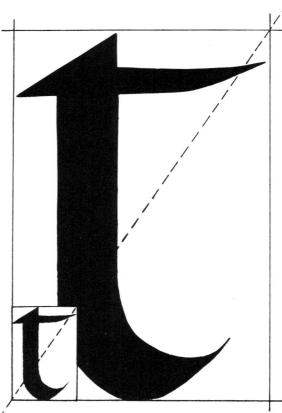

Enlarging or reducing artwork requires the use of a diagonal line drawn from corner to corner and extended beyond if needed.

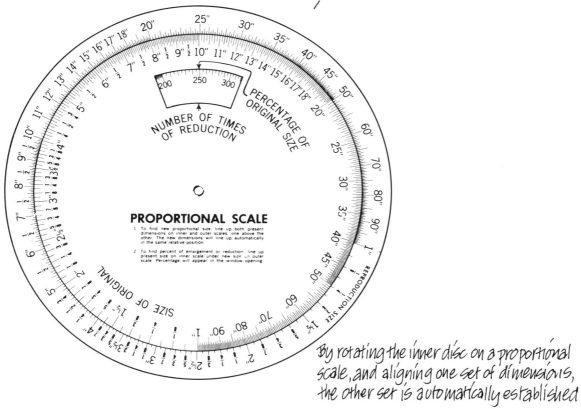

By rotating the inner disc on a proportional scale, and aligning one set of dimensions, the other set is automatically established

PHOTOSTATS

For calligraphic purposes it is better, in most instances, to reduce rather than enlarge work. Minor flaws can become very visible faults when blown up, whereas reducing work tends to further minimize small mistakes. Reduction certainly does not correct errors, but it does not accentuate them either. To more accurately evaluate what reduced or enlarged work will look like, use a photostat service. For a few dollars, a calligrapher can get a positive print made to his prescribed dimensions. A photostat is not an instant dry copy. It is a camera process that produces a paper negative from which a positive is made.

A positive photostat can also be used as artwork directly in the mechanical if there is some reason for not wanting to send original art to the printer. Be careful, however, because a less than precise stat can diminish the crispness of the final image. With each step away from the original art something is lost in fidelity, and stat shooting along with

shooting for the plate represents two steps away from the original form.

When ordering photostats there are three things that must be determined. The first is size. Will it be the same size, reduced, or enlarged? Use your proportional scale to find the percentage of change and pencil it in on your artwork at the bottom edge and outside the crop-marks. If, for example, the artwork is 3 inches × 5 inches (7.6 × 12.7 cm) and will be blown up to 4½ inches × 7½ inches (11.4 × 19 cm) then the notation should read, "Enlarge 150%" or just "150%." The second consideration is whether to use glossy or matte paper stock. Glossy prints produce crisp, solid blacks and are suited for line illustrations, type, and handlettering. It takes both enlarging and reducing copy well and can be pasted directly into a mechanical and used as shooting copy. Photostats printed on matte papers, however, hold a range of tones better and are used for photographs, paintings, and other continuous-tone art. Unfor-

original art (c.) can be reversed and reduced (l.) or enlarged (r.) by the photostat process.

tunately they are not of sufficiently high quality to use as shooting copy on the mechanical and can only serve to indicate size or placement. Finally, you must decide if a *positive* or *negative* stat is required. The process for producing a positive print is this: first a paper negative must be made. This is a paper image on which black lines are white and the background entirely black. The second step is to shoot again, using the negative. This reverses the image back to the same as the original art, black lines on white ground, except for whatever size changes may have been indicated.

COLOR

When a piece of art includes more than one color—and printers regard black as a color—it is necessary for the artist to separate the colors in order for them to be printed. Continuous-tone art, as we have previously discussed, is handled by the process camera. Flat color separation, whether in large mass areas or simple fine-line rules, must be taken care of by the artist. This may involve two, three, or four colors, but the procedure remains the same. Each color is separated into individual overlays. For example, a certificate might include these elements: a heading in olive brown, red majuscules, and body text in black. There are three methods by which these colors can be separated.

First Method. All the lettering, heading, majuscules, and text will be in black, and this is true in all mechanicals. The printer will provide color with his inks. The heading is cut away and saved, as are the majuscules. The remaining text portion is then rubber-cemented to a heavier mat or illustration board. A sheet of tracing tissue larger than the artwork is then taped on top of the body text. Each majuscule is then individu-

ally glued into precise alignment with the text. This represents the red plate. Finally, a second overlay is added in the same manner as the first, except this time the heading is pasted into position to make the olive plate.

Second Method. Again, all the lettering is written in black. At this point, two second prints, that is, positive photostats identical in size to the original, are made. The original is then cemented to a board and the heading and majuscules are opaqued out using a good, covering white (such as the Pelikan Graphic White). One photostat is taped over the black text lettering with everything other than the majuscules covered by the opaque paint. Or, if the areas are large, a sheet of opaque white paper can be glued on top to mask off the unwanted areas. Finally, the second stat is taped on with all but the heading covered. The advantage of this method over the first is simply that the photostat camera, by reproducing the original art in the same size for the red and olive overlays, has kept all the elements in their precise placement. Unlike the first method, there is no need to meticulously glue individual letters into tight spaces.

Third Method. In this process, which is the simplest of all if your printer is cooperative, you are only required to mount the artwork on a board with a covering tissue. Indicate the colors on the overlay by circling and writing the color down for each area. These are instructions for the printer. He will then shoot the original art three times, a negative for each color, and simply paint out of each negative those elements that are not required. This is essentially the same process as the second method, but the printer does the work.

Color Separation

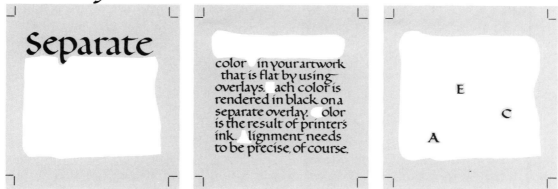

First Method: The artist is required to manually cut the original art. Each cut portion will represent a different color and is pasted into position on a separate overlay.

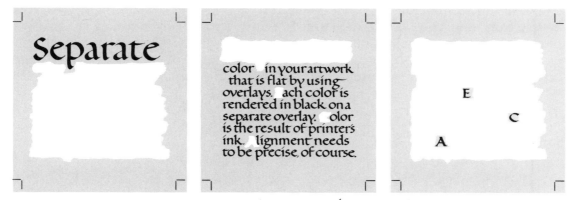

Second Method: Two positive photostats, identical in size to the original art, are made and glued to overlays. All areas, other than those representing the desired color, are opaqued out.

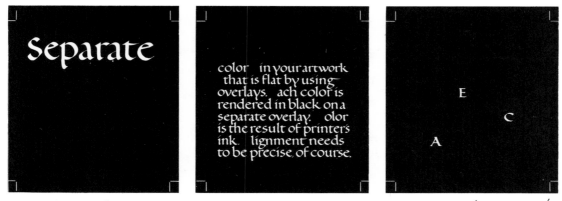

Third Method: The printer shoots the art three times and, following the artist's instructions as indicated on an overlay, will paint out the unwanted areas from each negative.

COMPLETING THE MECHANICAL

When all the elements of the mechanical have been completed, one final check should be made of all the details. Using the example of our three-color assignment involving black, red, and olive, executed by the first method, the complete mechanical should be constructed in the following manner. The base plate is black and is represented by the text material mounted on a heavier board. A light, nonreproducible blue pencil line encloses the image area. Hairline black crop marks are also placed in each corner. Check the entire surface for dirt, rubber-cement residue, and other unwanted marks that will be picked up by the camera. These blemishes should be brushed off, erased, or painted out. Since this mechanical calls for two overlays, it would be wise to add at least three registration marks in the form of fine-line crosshairs inside a circle, which can be purchased in a roll. The symbols are self adhesive and can be peeled from the roll and easily positioned. Printers use these marks to establish perfect alignment for all three plates.

If, at this last minute, final proofing finds a spelling error, the offending letter can be covered with the correct letter written on another piece of paper. However, if the space is too tight for this corrective method, I simply write the correct letter directly on top of the wrong one. After it dries, I paint out all the exposed, extraneous portions with white. I prefer this method over scratching out, which usually mars the surface to the point where any subsequent letters will blur and spread. Another

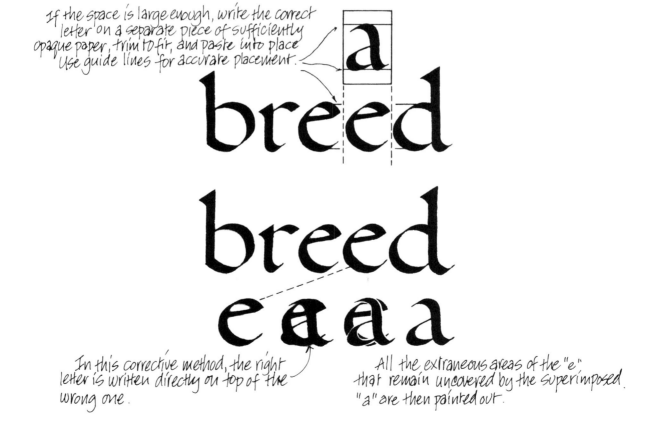

If the space is large enough, write the correct letter on a separate piece of sufficiently opaque paper, trim to fit, and paste into place. Use guide lines for accurate placement.

In this corrective method, the right letter is written directly on top of the wrong one.

All the extraneous areas of the "e" that remain uncovered by the superimposed "a" are then painted out.

method requires painting over and then lettering on top. This is exceedingly difficult since the paint surface does not permit clean, crisp lettering.

Finally, after all corrections and adjustments have been made and the surface found to be completely clean, pencil in "black plate" along the bottom edge and out of the image area defined by the crop marks.

The first overlay, with the majuscules in place, is the red plate and should have both crop marks and registration marks in alignment with those on the black plate. The next overlay is the olive plate, and this will have the heading pasted in position. Again, crop marks and registration marks need to be placed in alignment with the two plates underneath. An olive and red swatch, each at least an inch (2.5 cm) square,

should be attached to the respective overlays. These color samples can be your own or taken from the Pantone Color Specifier. In either case, they give the printer an indication of the color you want matched. Reduction dimensions should be indicated on each plate and are usually expressed as percentages. If the image area is 10 inches (25.4 cm) wide and the final form is intended to be five inches (12.7 cm), the notation should read "50% reduction." Another method less frequently used is drawing arrow heads between the crop marks at the bottom edge and writing in "reduce to 5 inches." For both appearance and added protection, a sheet of brown kraft paper is cut to size, taped or glued to the back of the board, and then flapped over the entire mechanical.

Selling Your Work

FOR MANY CALLIGRAPHERS, acquiring great skill in constructing letterforms or producing well-designed compositions is sufficient reward for their time and energies spent. The practice of calligraphy becomes a gratifying pastime and is its own justification. For others, however, the proof of one's skill is in the marketing of the end product.

The calligrapher's "product" in that case is more than the esthetic piece lettered for pleasure. It is the talent for letter construction and design abilities put to use, and purchased and enjoyed by a client.

WHERE IS YOUR MARKET— WHO BUYS?

Family and other relatives, friends, community and social groups, all represent one facet of the buying public. This segment of potential customers may be broadly defined as individuals and organizations who have not been exposed to a quantity of calligraphic examples and frequently cannot make knowledgeable comparisons. For the most part, they are simply aware that yours is a valuable skill, a functional craft they are unable to perform themselves. Within this group, however, there is a great variety of job possibilities, some imaginatively conceived solely by the client. In one case, I provided nursery rhymes lettered on precut paper discs that were subsequently laminated on plastic plates and used as a birthday gift for a child. Most commissions are more routine than this, but nonetheless can be challenging for their own reasons. Some examples are listed below; chances are I have omitted others you have experienced.

Envelopes. These can be envelopes containing invitations or announcements

celebrating a variety of occasions. They are mainly used for formal rather than informal affairs, ranging from weddings, anniversaries, births and birthdays, bar mitzvahs, to large charity functions. The informal envelope implies smaller gatherings, but nonetheless suggests a certain selectivity through the use of calligraphy.

Invitations. Handlettered invitations along with the envelopes are rare commissions since the cost can be high, determined by the number, of course.

Place Cards. While these are sometimes included with handlettered invitations and envelopes as a complete package, this need not be the case. They are frequently ordered separately for as few as eight or as many as 80 guests.

Names. One of my first lettering jobs developed immediately after completing a course in Manuscript Lettering taught by Ralph Douglass, author of *Calligraphic Lettering.* This occurred at the end of my second year in college and entailed filling in graduation certificates with the names of those students who were doubtful candidates up to and including the last minute! I have long since learned that filling in names can be a lucrative job, particularly on a sustaining basis. One of my students informed me recently she performs this type of lettering once a month on an average of 150 certificates. On further discussion I learned she worked for a large, nationally prominent insurance company, which had discovered her calligraphic talents and asked if she would be interested in lettering certificates awarded each month to graduates of their trainee program. She does this as a free-lance commission each month, exclusive of her regular job. Repetitive-

ness can lead to boredom, naturally, but an ongoing account of this kind is most desirable and the regularity of a paycheck can be very soothing! Within this general category are also name tags for business meetings and small conventions.

Signs. With certain size limitations, pen lettering functions very well for signs, posters, handbills, and general announcements. For very large signs, of course, brush lettering is more suitable. I feel calligraphy functions best within a certain esthetic scale and in a particular context. Perhaps the best representations of this concept are the small, dignified signs and price tags most frequently associated with specialty shops, the better jewelry stores, and "smart" boutiques. Even the signs announcing a sale are usually treated decorously.

Letterheads, Business Cards, and Logos. Ideally, a job of this type should be a complete package in which the calligraphic designer is able to unify design concepts in all the graphic material. Frequently this is not the case, unless it is for a new and small company, or the self-employed professional. More frequently, I have been asked to simply redesign just the business card using calligraphy. Whenever possible, having one foot in the door, so to speak, I try to convince my client to extend the business card motif and the idea of design continuity to include all his printed matter.

Certificates and Awards. This is one job category that truly allows the calligrapher to shine. Since it is likely to be a one-of-a-kind presentation, you will probably be given a free hand with no

...I can't remember a day when I didn't look forward to going to the office...

In recognition of his fiftieth anniversary as a practicing attorney, the members of the Turcotte Family wish to confer this commemorative certificate upon:

Eugene O. Turcotte

this 17th day of May, 1980, with love, honor, and respect.

The Turcotte Family

Gardner, Massachusetts

This certificate was rendered in black, green, and olive, with portions outlined in gold.

color restrictions and total control over the design. Sometimes, even the size is left up to you. Given such free rein, the calligrapher should be able to exhibit his skills to the fullest. In a practical sense, a job of this type offers an opportunity to advertise your talents in their best possible light and probably to a circle of potential clients who would attend the honoring ceremony.

Menus. Calligraphic lettering is suited for menus of all kinds and can project visual images that range from the very formal to the more exotic. Menus can even be provided individually—each handlettered—for small formal dinners.

The other group of potential customers is represented by the professional market: advertising agencies, graphic-design studios, publication houses, and generally all producers of visual communication that use the print media. Here the calligrapher is confronted by more knowledgeable, experienced art people with finely tuned design instincts who are fully capable of evaluating the quality of your skills in terms of their needs. Work done on this professional level is frequently more varied and challenging. Your calligraphic contribution may represent only a small component piece of a larger, more intricate whole, such as a book-jacket title. Usually a budget, sometimes quite generous, is allotted for the total piece, and the amount allocated for handlettering as part of that budget can be high. The more favorable pay scale is, of course, commensurate with the pressure of competition in this marketplace and its insistence on top-quality design.

The hierarchy of letters in the professional market is dominated by typography, of course, followed by the use of the so-called "rub on" letters, which are alphabets printed on plastic sheets with adhesive backings. There is also built-up or constructed lettering, and lastly, calligraphy. In order for pen lettering to participate more fully in the professional market areas, two events must occur. One is the continued and rapid growth of general awareness and interest in calligraphy, which in time would be reflected in graphic-design studios. The current attitude among designers seems to be personal appreciation of the craft, but limited use. They feel, I suppose, that historical letterforms project such strong, archaic images it is hard to integrate them into contemporary graphics. The second consideration requires the calligrapher to explore, experiment, and, perhaps, create letterforms that will blend with modern design attitudes.

The most prevalent use of calligraphy in the commercial market today would seem to be in the following areas:

Book Jackets. This is probably the most prominent outlet for handlettering. Because titles do reflect in spirit the contents of the book, and with hundreds of new titles each year written on a vast variety of themes, there is ample room in this area for handlettering to compete successfully with type.

Album Jackets. It is also true that there are many new record albums produced each year, but unfortunately the music markets are less suited for handlettering. More evident on these jackets are constructed letterforms. Calligraphy is more frequently seen on classical-music album covers.

Advertisements. There seems to be a growing use of handlettering in both

newspaper and magazine advertising. To a great degree its use is determined by either the type of product or the service being promoted, but compared to a relatively few years ago when handlettering seemed to appear in advertisements only at Christmas and Easter time, it is gratifying to see its year-round use. These examples usually do not involve the total advertisement, however, and are primarily found in headings and subheadings.

Logotypes. Calligraphic logos are no doubt being used, but for smaller businesses rather than the larger corporations. The reason for this, as we have previously stated, has to do with our machine and computer age, a growing sense of the impersonal, perhaps. Calligraphy is an expression of the human hand and its most beguiling characteristic is its warmth, its humanity. It should be understandable, therefore, why these two divergent esthetic directions are difficult to reconcile graphically.

Labels and Packaging. The use of handlettering for labels is most often seen on wine bottles and also on both labels and packaging of gourmet food containers.

UNIT PRICING

Lettering the single piece—the one-of-a-kind work—is most often commissioned by individuals or organizations. It may be a certificate, testimonial, diploma, scroll, or simply name tags. Establishing a price for your work depends on several factors, the most obvious being the overall difficulty of the piece. The degree of difficulty is estimated by the amount of copy involved, whether color is called for, the size, the type of working surface, the alphabet chosen, and the demands of that particular hand.

Let me elaborate on size as a significant consideration. The relationship between size and difficulty does not necessarily mean the bigger the piece the greater the difficulty. It is more important to consider the amount of copy required for the allotted space than the size of the space itself. There are times when a client may want a lot of text material lettered in a small area. This can be much harder to execute than doing the same amount of lettering in a larger space.

The cost of materials should also be considered if it goes beyond the most basic items. The wear and tear on pen nibs, the amount of ink or paint used on a single project, are costs that are hard to evaluate and can easily be expenses absorbed into the fee assessed the client. However, extraordinary expenses such as quantity amounts of stock not provided by the client, the use of genuine sheepskin, vellum, 100% rag papers, or gold leaf are costs that should be passed along directly to the customer.

Some calligraphers base their price on an hourly rate, which automatically covers the difficulty of the project. This method is most successful for highly experienced artists who, based on past performances, can reasonably estimate the amount of time involved, given all the above considerations. Another approach is to set a base price for all single-unit pieces—perhaps $50—and then adjust it accordingly when all elements are evaluated.

Should you be asked for any service beyond the actual lettering, an additional assessment must be made. Some clients prefer the calligrapher handle the whole project, which might even in-

when
Meredith was six
she and her older sister
would keep me company at
my studio on saturday mornings
and while I painted she
would write notes to me
on scrap matboard ...

Be quit sheee Do not wake the chiuld up Plese

Meredith is eleven today
and sometimes I almost
wish she
was six again and
I was five
years younger

This is a freehand, "one-shot" exercise of calligraphic rambling. I used no guidelines and
the layout developed as the lines progressed. Practicing in this manner is a fun way to loosen up!

clude having artwork framed, matted, bound, or packaged. If this is the case, the cost of materials and labor, along with a service charge, should be added to the bill.

Finally, if the client wants the completed work tomorrow and the deadline imposes a genuine hardship on you, then by all means charge for it.

QUANTITY PRICING

Pricing a quantity of identical calligraphic pieces simply means establishing a cost of one item and then multiplying by the total number. Say, for instance, these units are envelopes. First make a determination for one envelope. Some calligraphers charge by the line with a three-line minimum, above which an additional amount is assessed. Let's say the current base figure for three lines on an envelope is $1.50. Should an address call for only two lines, the price remains the same. If a return address is required—and this is a rare request in my experiences—the base cost is not doubled to $3.00. (You could price yourself out of the job!) Even though this may mean an additional three lines, consider an increase by half to $2.25 per envelope. This is a more enticing figure to your client, especially if you point out he will be getting double the amount of work for considerably less than twice the price. If a large number of envelopes are involved, this "discounted" price will still generate a substantial profit for you. As you are probably aware, when lettering a large number of pieces identical in layout, a certain rhythm and flow develop that ease the tedium and speed the work.

Another pricing method for quantity work is the "package" price. Here the calligrapher is typically required to let-

ter all the pieces for a small social occasion. This might include invitation, envelope, and possibly a place card or menu if dinner is included for 12 to 18 people. The package price for each unit of three pieces would probably range from $9 to $12, depending on the difficulty of the hand. The higher price of $12 should be charged, for instance, if Copperplate is the selected alphabet. It would be a very appropriate style of lettering but it is a demanding technique (at least for me!), with little margin for error. Under these circumstances the maximum figure is well justified. For such formal occasions the client often furnishes special stock, so paper costs would not be a factor in pricing.

PRICING THE MECHANICAL

A mechanical, as previously discussed, is camera-ready art. It contains all the information a printer needs to reproduce the work in the quantity, color, and size demanded by the client.

Establishing a price for just the mechanical involves all the considerations accounted for in single-unit pricing, except for the cost of materials, which in most instances is negligible. However, when color separations are required, which makes the job more complex and time consuming, this should be covered in the overall fee. Photostats are also frequently used in the preparation of a mechanical; this cost, too, should be passed on to the client (see page 161 for production methods).

Compared to the one-of-a-kind piece, everything else being equal, the price of a mechanical should be lower in cost. Preparing material for reproduction allows the calligrapher the luxury of whiting out small mistakes, as well as pasting up and juxtaposing blocks of

copy. This degree of flexibility is obviously not available in lettering the single, original piece, where a mistake frequently means doing the entire job over! The price of a mechanical, therefore, in its most simple, uncomplicated form, should probably not exceed $50. It can, of course, run into hundreds of dollars, depending on its complexity.

THE TOTAL JOB

There are times when a client prefers the artist handle the entire job from beginning to end, delivering to him the printed matter in its final form. When this situation arises, the calligrapher should be capable of rendering such service with ease and confidence.

Information about production methods can obviously be learned from textbooks (see the Bibliography), but a more practical and interesting way would be directly from a printing house. It is definitely to the calligrapher's advantage to establish a congenial working relationship with a printer. His congeniality will increase in direct proportion to the amount of work you give him! If the results are satisfactory, then by all means continue your patronage. In the process, a lot of valuable behind-the-scenes information will be imparted. Some of the things you should try to learn immediately are both the maximum and minimum size his presses can handle; whether plates are made on the premises or elsewhere; the variety, size, and quality of stock usually carried in their inventory, along with his selection of colored inks. It is also important to know whether work can be trimmed, scored, and folded on the premises. If all the work can be done "in house," chances are you will get the completed job much faster. When bits and pieces

have to be subcontracted, the job will take that much longer. Knowing something about your printer's equipment and inventory allows you to work within his limitations and avoid situations where your artwork exceeds the capabilities of his shop. At the very least, you will know when a job can be better handled by a larger, more comprehensive printing house than your neighborhood jobber.

In accepting the responsibility for seeing a job through to completion, your first consideration should be establishing the client's precise needs. Color and quality of paper should be discussed. Size and quantity should also be firmly established, along with color selection if that is a factor. Finally, have your client review the finished mechanical and initial it to indicate his approval.

With this information in hand, next consult the printer to determine the overall cost of the complete job. This figure should be passed along to your client to see if it is acceptable. The price you charge your client for the total assignment would then include cost of production, a fee for its supervision, and the initial charge for the mechanical.

VARIABLES IN PRICING

There is no fixed formula a calligrapher can use to set a price for his work. As in most service-oriented businesses, price is determined by many variables, ranging from geographic location to the quality of the merchandise. In larger cities, where competition is severe, old established firms vie with free-lance calligraphers for major commissions. In other parts of the country, calligraphic services are not as freely available and

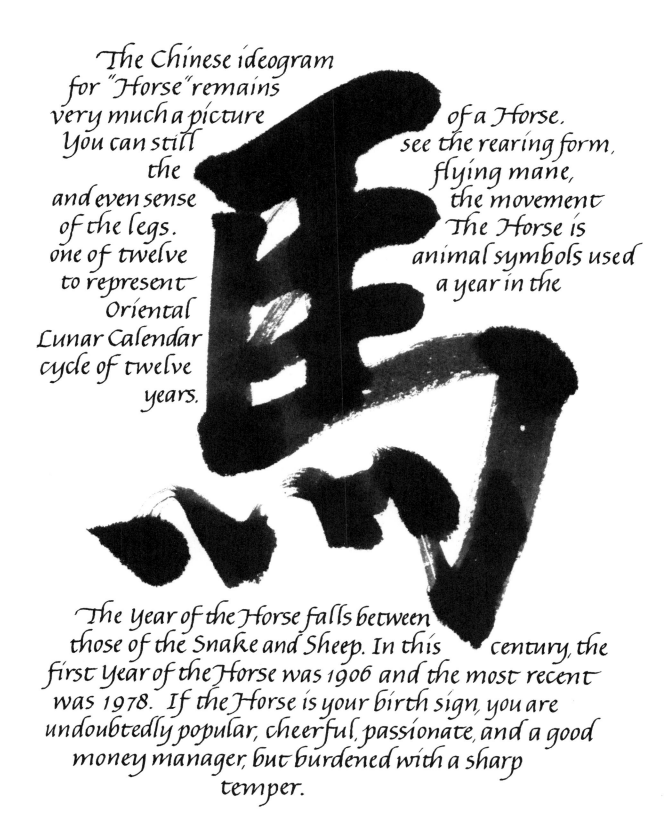

The Chinese ideogram for "Horse" remains very much a picture of a Horse. You can still see the rearing form, flying mane, the movement and even sense the movement of the legs. The Horse is one of twelve animal symbols used to represent a year in the Oriental Lunar Calendar cycle of twelve years.

The Year of the Horse falls between those of the Snake and Sheep. In this century, the first Year of the Horse was 1906 and the most recent was 1978. If the Horse is your birth sign, you are undoubtedly popular, cheerful, passionate, and a good money manager, but burdened with a sharp temper.

This design is one of twelve plates proposed for a lunar calendar project.

price might well be what the market can bear.

In my experience, when a calligrapher is first confronted with a selling or price-setting situation, he is too modest about his talent and tends to place a low dollar value on his service. However, with each venture into the commercial market his confidence and experience increase; soon pricing becomes a much more realistic assessment of his value. Establishing an equitable price in his own mind, however, does not automatically guarantee the potential client will feel the same way. The professional calligrapher will, on occasion, encounter unsophisticated attitudes that seem to suggest there is no difference between handwriting and handlettering. To write beautifully, some clients might imply, is only a casual but happy accident, with some individuals more manually dexterous than others. The suggestion might also be made that there is no learning, no training, no professional maturation process involved. The calligrapher should rebut this misunderstanding if the client is receptive to discussion, and a definite effort should be made to "educate," if only to explain in greater depth what the job might involve. Calligraphy, unfortunately, has not as yet achieved that happy state of being in continuous demand. As a result, it must, at times, justify itself, both verbally and through the beauty of its design.

Glossary

Acrylics. Common name for the so-called plastic paints in which pigments are dispersed in an acrylic emulsion. They can be thinned with water but are ill suited for calligraphic purposes.

Ascender. Portion of a minuscule letter that rises above the body, requiring another guideline.

Asymmetrical. Off-center, opposite of symmetrical. An asymmetrical design is one in which the visual elements are weighted more heavily to one side.

Banknote Script. General term describing Copperplate lettering.

Beam Attachment. Attachment affixed to a compass that enables one to draw very large circles and arcs.

Blackletter. Another name for the Gothic alphabet, effectively describing its dense, compact appearance.

Body. Portion of a letter that is exclusive of ascenders and descenders and that can be contained between two guidelines.

Bookhand. Humanist hand of the 15th century developed by Roman scholars following the rediscovery of the Carolingian alphabet found on ancient Roman manuscripts.

Broad-edge. Pen nibs having a cut or chiseled writing edge, as opposed to the pointed pen.

Broadside. Large sheet of paper printed on one side only, published to present one's views on a controversy or to make an official proclamation (now archaic).

Burin. Pointed instrument used for fine-line work by engravers.

Burnisher. Agate-tipped hand tool used to polish gold leaf to a high luster.

Carolingian. Alphabet discovered in France in the late eighth century through the efforts of Emperor Charlemagne, which represents the first appearance of a true minuscule alphabet with ascenders and descenders.

Casein. Curd from skim milk used as a paint binder and adhesive.

Centered. Term used to describe the symmetrical balance of visual elements equally distributed on both sides of a center line.

Chancery Cursive. Ornate form of the Italic alphabet, which takes its name from the Papal Chancery's endorsement of its use in the writing of papal briefs in the 15th century.

Chamois. Piece of doeskin, well suited for pen wiping because of its lintfree, smooth surface.

Cipher. Two or more interlaced letters primarily used for identification or ornamentation, as on silverware, social stationery, and so forth. (See *Monogram.*)

Copperplate. 18th-century hand that developed when the scribe adopted the pointed nib in order to emulate the fine lines of the engraver's burin.

Copyfitting. Typographic term describing the process of converting a typewritten manuscript into printed matter to fill a predetermined space.

Counters. Spaces within letters that help determine the accurate shaping of letters; sometimes referred to as negative spaces.

Cropmarks. Hairline notations at each corner of a mechanical that indicate the borders of the printed page.

Crow-quill. Pointed pen, tubular in design, suited for drawing very fine lines yet flexible enough to draw the swells and shades required for Copperplate.

Cuneiform. Sumerian writing system in which pictorial symbols were imprinted into damp clay tablets by means of a wedge-shaped reed.

Cursive. Writing that flows, with letters that are frequently joined and angles slightly rounded.

Deckle. Frayed edge on handmade papers caused by the wooden frame in which the paper pulp is contained. This edge can be artificially duplicated by machines.

Demotic. Common form of Hieroglyphics used for everyday affairs in ancient Egypt.

Descender. Stroke from the body of a letter that falls below the bottom guideline.

Designers colors. Opaque watercolors suitable for calligraphic use. Also referred to as gouache, they are available in tubes, jars, and cakes.

Dipping. The process by which nibs are filled with ink, as contrasted to filling fountain pens or filling a pen reservoir by means of a brush.

Dividers. Mechanical drafting tool similar to a compass with two pointed arms; it is used to take and repeat a fixed dimension.

Dry Cleaner. Mildly abrasive powder contained in a cloth pouch that is used for gentle cleaning of large areas of paper or for lightly scuffing the surface of very smooth paper to raise the tooth.

Elbow Nib. Pen designed with an "elbow" in the shaft to better accommodate the severe writing angle of the Copperplate hand.

Elite. Type size in typewriters having 12 units to the inch. Elite is a shade smaller than pica.

Fillers. Decorative designs made with the pen to fill open areas in a body of text. These are most often seen in illuminated manuscripts.

Finisher. Stroke flourish extended from the last letter at the end of a line or paragraph, used to fill and decorate an open area.

Flush. Setting type or handlettering lines so that one margin (or both) of the text is even along its edge; having no indentation. (See *Ragged.*)

Format. Shape, size, or general design, as in the format of a magazine.

French Curve. Curved drafting tool or template, made of plastic or metal, used to draw intermediate arcs or ovals that are not exact circles.

Gothic. Period of European history beginning about the 12th century during which Blackletter came into prominent use. The dual alphabet—majuscule letters designed to be used solely with minuscules—also came into being in this period.

Gouache. Technique of painting with opaque watercolor; commonly used to describe opaque watercolors generally, as with designers colors.

Grain. Direction of fibers in a sheet of paper. Machine-made papers usually have a grain or predominant direction in which the fibers run; handmade papers do not. Paper can easily tear or be folded along its grain.

Grams per square meter. Metric weight measurement for paper, based on the weight in grams of a square meter of a given paper. 20-pound bond is equivalent to 75 grams per square meter, for example.

Gravure. Intaglio printing process in which the image to be inked on a plate is etched *below* the plate surface.

Guidelines. Penciled-in or imaginary lines that contain the vertical boundaries of a letter; for example, the two guidelines for majuscules and four for minuscules.

Hairlines. Fine lines, usually drawn at the finish of a stroke, used both for decoration and for explaining an awkward counter. They are most frequently used with Blackletter.

Halftone. Continuous-tone art comprising gradations of tonal values from black to gray to white, such as a photograph. (See *Line Art.*)

Half Uncial. Lettering hand that overlapped the Uncial and Rustica and was, roughly speaking, the predecessor of Carolingian. (See *Uncial.*) It has the appearance of a minuscule alphabet, but is not.

Heading. Word or line at the beginning of a manuscript that has been emphasized either through size, color, or placement.

Hieratic. Cursive form of writing used by the ancient Egyptian priests that, in the hierarchy of Egyptian letters, fell in between Hieroglyphics and Demotic.

Hone. To sharpen; also, a small piece of finely textured glass used to delicately remove the burr from a nib.

Humanist. Renaissance period in Italy and elsewhere during which scholars sought to restore many of the cultural refinements of ancient Rome.

Ideogram. Symbol used to represent an idea rather than a sound. (See *Phonogram.*)

Illumination. Process by which colors and gold leaf are applied to a manuscript to decorate and emphasize portions of a page and bring it "to life."

Interlinear Spacing. Amount of space between lines of lettering.

Italic. Writing that is slanted; also, the tilted alphabet that developed from Humanist Bookhand and eventually became an alphabet with joins, creating a continuous, flowing script.

Join. Line connecting one letter directly to the next, as in the Italic alphabet, which features both horizontal and diagonal joins.

Justify. To adjust the amount of space between words in order to make lines of type or lettering fit within a specified measure and be even at both margins—flush left and right.

Kid. Surface texture of Bristol board of medium tooth, much favored by calligraphers, which resembles soft, undressed kid.

Layout. "Floor plan" or preliminary drawing indicating the placement of all design and text elements on a page.

Leading. Typographic term (pronounced *ledding*) indicating the amount of space between lines of type. In metal composition this is achieved by actually inserting thin metal strips (*leads*) between lines; in photocomposition, space alone is inserted.

Letterpress. Printing process in which the plate image to be inked is *above* the surface of the plate.

Logotype. Two or more letters combined into a design symbol, usually abbreviated to *logo*.

Line Art. Any art that is solid black, with no tonal gradations, such as lettering, line drawings, or rules.

Majuscule. Capital letter, which can be contained within two guidelines and has no ascenders or descenders.

Mechanical. Camera-ready paste-up of all lettering and design elements in exact position on illustration board, complete with instructions for the printer, either in the margins or on an overlay.

Minuscule. Small or lowercase letter, requiring four guidelines to contain ascenders and descenders.

Monogram. Combination of two or more letters into a design in which one letter forms part of another and cannot be separated from the other. (Cf. *Cipher*, in which the letters are merely placed together, not bound into an overall design.)

National Hands. Refers to the proliferation of a great variety of hands following the fall of the Roman Empire. The chaotic conditions during this period essentially stalled the development of letters, as the forms practiced were not progressive.

Negative. Reverse photographic image on film or paper (see *Photostat*) in which white becomes black and black becomes white. This is the first print of the photostat process. The term is also used by printers to indicate the film negative for the printing plate.

Nib. Actual writing instrument, separate from the holder; interchangeable with *pen*, or *pen point*.

Nibbing. Making one's own nib from a quill or reed; in particular, trimming of the tip to form the writing edge.

Opaque. Impenetrable by light; of such density as to cover or conceal what lies underneath.

Offset Lithography. Printing process in which the inked image is on the same plane as the metal or plastic plate. The inked plate transfers (offsets) the image onto a rubber blanket which, in turn, transfers the image onto paper.

Overlay. Sheet of transparent paper or film placed over artwork or mechanical in order to protect it, indicate instructions to the printer, or indicate color separations where more than one color is used.

Palmer. Penmanship instruction utilizing the script form of the Copperplate hand.

Pantone. Color system used by commercial artists and designers to indicate particular

colors on mechanicals. The system permits close coordination between artist and printer in color selection, and in duplication of the colors with printers' inks.

Papyrus. Early writing material made from the pith of a sedgelike plant, native to the Nile region. Papyrus was used by the ancient Egyptians, Greeks, and Romans.

Parallel Rule. Drafting instrument attached to a drawing board consisting of a single straightedge riding on a track of wire or waxed twine. It is used in place of a T square.

Parchment. Writing material made from the skin of the sheep or goat.

Penlifts. Writing process whereby a pen is raised from the paper at the completion of a stroke. The fewer the penlifts, the faster the writing, although the techniques in writing certain letterforms require intermediate lifts—as in Copperplate—in order both to rest the hand and to better draw the succeeding portion of a letter.

Pen Width. Width of the writing edge in a broad-edge pen when drawn at a perfect vertical. The width is used as a standard measuring device to establish proportions between body, ascender, and descender.

Phoenicians. Inhabitants of a coastal strip on the Mediterranean, now in Syria. Of Semitic origins, the Phoenician alphabet contained 22 letters and showed characteristics in common with ancient Egyptian writings as well as the Semitic forms.

Phonogram. Character used to represent a word, syllable, or speech sound.

Photostat. Photoprint (commonly called a *stat*) used in place of actual artwork on mechanicals to indicate size, cropping, and position. The photostat camera first produces a paper negative, from which a positive stat is made. The newest technology is now capable of producing a positive stat directly, eliminating the need for a negative.

Pica. Unit of measure in typography: six picas equal one inch. Also, designation of typewriter type having 10 units to the inch (as opposed to elite type).

Pickup. Plastic wedge used to remove excess rubber cement.

Pictogram. Symbol that pictorially illustrates an act or an idea.

Pith. Soft, fibrous core of a plant stem or feather.

Plate Finish. Surface finish on paper that is extra smooth and hard. Plate-finished stock is excellent for the Copperplate hand, which has very fine lines drawn with a pointed nib, but is difficult to use with other calligraphic hands.

Pointed Nib. Steel pen nib having a single slit at its point. Varying principally in their degree of flexibility, these nibs are found on the elbow nib and crow-quill pens used for Copperplate, and on the everyday fountain pen.

Pound. Weight measurement for paper, based on a ream (480 to 500 sheets) of that paper. Thus, a ream of 20-pound bond weighs 20 pounds. (See also *Grams per square meter.*)

Printing Plate. Metal or plastic surface carrying the inked image, which either transfers the image directly to the paper or, as in offset lithography, to a rubber blanket that in turn transfers the image onto paper.

Rag Content. The quality of a paper is determined by its ingredients. Most common papers are made of wood pulp, while high-quality papers contain a high proportion of linen or cotton fibers (known as *rag content* because the pulp is often made from linen or cotton rags).

Ragged. Arrangement of lines of lettering or type so that either the left or right margin is uneven.

Ream. Measured quantity of paper of any dimension, usually 480 to 500 sheets. A printer's perfect ream contains 516 sheets.

Reed. Tubular plant stalk from which a pen can be cut.

Registration Marks. Graphic marks, usually a cross in a circle, that are applied to mechanicals so the printer may position two or more separations and/or negatives in perfect register.

Reservoir. Metal device, removable or permanently attached to a nib, that holds a quantity of ink or paint.

Roundhand. Interchangeable term for Copperplate, which derives its name from the appearance of the letterform.

Rubricate. To write in red on a manuscript, particularly on illuminated pages.

Ruling Pen. Drafting instrument used for drawing lines of varying degrees of thinness, usually used in conjunction with a straightedge.

Rustica. Early fourth-century letterform that preceded the Uncial alphabet and required a very steep pen angle.

Sable. Quality hair used in the finest of watercolor brushes.

Scaling. Process of determining the percentage to which artwork is to be enlarged or reduced, using geometric proportions or a scaling wheel.

Shades. Copperplate strokes that have a thickness and a squared-off end.

Solid. Typographic term describing lines of type that have no leading in between.

Stat. See *Photostat.*

Stylus. Pointed instrument used to impress a drawing into a surface.

Swells. Copperplate strokes that begin and end as hairlines, with a tapering bulge in the middle.

Taboret. Artist's side table, used with an easel or drawing board, for supply storage and for additional working surface.

Tempera. Common term for opaque watercolors and, more particularly, poster colors.

Template. Paper, plastic, or metal device with cutouts describing specific forms (circles, ovals, squares, and so on).

Textur, Textura. More accurate description of Blackletter (from the Latin, meaning *texture*).

Trajan Column. Roman monument erected in A.D. 114 from which we can trace our use of the classic Roman alphabet.

Transparent. Mediums, such as transparent watercolor, which are capable of transmitting light. (See also *Opaque.*) As these mediums do not in fact transmit light perfectly clearly (as does pure water), it would be more accurate to describe them as translucent.

Triangle. Plastic or metal device used in conjunction with the T square to draw vertical lines and to establish accurate diagonals.

True Edge. Metal strip attached to the left-hand edge (if you are righthanded) of a drawing board, along which the T square can ride evenly and smoothly.

T Square. Drafting device used to accurately construct horizontal lines.

Typography. Composition, arrangement, and design of printed matter from movable (including photomechanical) type.

Uncial. Majuscule letterform (pronounced *un'shal*) found in Greek and Latin manuscripts of the third to eighth centuries A.D., which derives its name from Roman examples measuring an *uncia* or inch in height.

Value. Degree of lightness or darkness in color.

Vellum. Writing material made from the skins of newborn calves, goats, or sheep.

Vermillion. Red pigment made from mercuric sulfide and found on ancient Egyptian manuscripts. It was popularly used on medieval manuscripts, and can be duplicated today by cadmium red light.

Versal. Letterform deriving its name and characteristics from the first letter of a verse, which was enlarged and painted for decoration and emphasis.

Waterproof. Characteristic of inks that are resistant to water after they dry; it does *not* imply permanence.

Watermark. Faint, translucent design impressed into paper as it is made that identifies the maker or the sheet size; it is visible when the paper is held up to the light.

Bibliography

Bickham, George. *Universal Penman.* New York: Dover Publications, Inc., 1954.

Chiang, Yee. *Chinese Calligraphy.* Cambridge: Harvard University Press, 1954.

Craig, James. *Designing with Type: A Basic Course in Typography,* Rev. Ed. New York: Watson-Guptill Publications, 1980.

Craig, James. *Production for the Graphic Designer.* New York: Watson-Guptill Publications, 1974.

Douglass, Ralph. *Calligraphic Lettering,* Third Ed. New York: Watson-Guptill Publications, 1967.

Ecke, Tseng Yu-ho. *Chinese Calligraphy.* Boston: David R. Godine, in association with Philadelphia Museum of Art, 1971.

Fairbank, Alfred. *A Handwriting Manual.* New York: Watson-Guptill Publications, 1975.

Fairbank, Alfred. *The Story of Handwriting,* New York: Watson-Guptill Publications, 1970.

Gates, David. *Lettering for Reproduction.* New York: Watson-Guptill Publications, 1969.

Goudy, Frederic W. *The Alphabet and Elements of Lettering.* New York: Dover Publications, Inc., 1963.

Heller, Jules. *Papermaking.* New York: Watson-Guptill Publications, 1978.

Hewitt, Graily. *Lettering.* New York: Pentalic Corporation, 1976.

Hunter, Dard. *Papermaking: The History and Technique of an Ancient Craft.* New York: Dover Publications, Inc., 1978.

Johnston, Edward. *Writing & Illuminating & Lettering.* London: Sir Isaac Pitman and Sons Ltd., 1906.

Kuwayama, Yasaburo. *Trademarks and Symbols.* New York: Van Nostrand Reinhold Company, 1973.

Lamb, M. A. (Ed.). *The Calligrapher's Handbook.* New York, Pentalic Corporation, n.d.

Lem, Dean Phillip. *Graphic Master.* Los Angeles: Dean Lem Associates, 1974.

Mayer, Ralph. *The Artist's Handbook.* New York: The Viking Press, 1970.

Nesbitt, Alexander. *The History and Technique of Lettering.* New York: Dover Publications, Inc., 1957.

Svaren, Jacqueline. *Written Letters: 22 Alphabets for Calligraphers.* Freeport, Maine: Bond Wheelwright Company, 1975.

Thompson, Tommy. *Script Lettering for Artists.* New York: Dover Publications, Inc. 1965.

Turbayne, A. A. *Monograms & Ciphers.* New York: Dover Publications, Inc., 1968.

Wotzkow, Helm. *The Art of Handlettering.* New York: Dover Publications, Inc., 1957.

Index

Edited by Michael McTwigan, Jennifer Place
Designed by Jay Anning
Graphic Production by Hector Campbell
Set in 11 point Trump Medieval